dishes

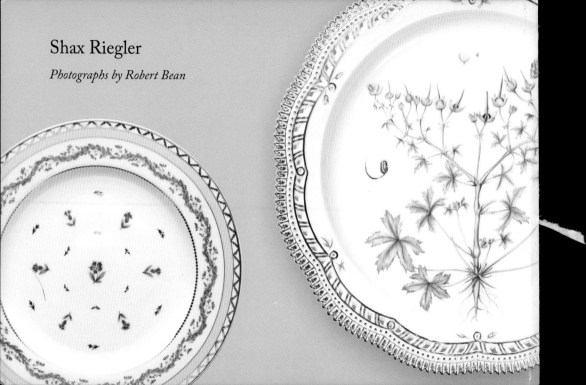

Shax Riegler

Photographs by Robert Bean

CONTENTS

UNMARKED NINETEENTH-CENTURY ENGLISH PLATE IN THE IMARI STYLE

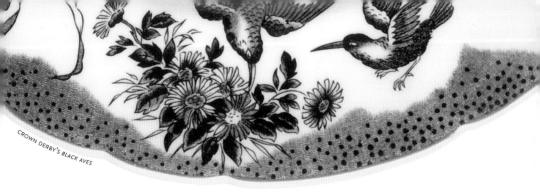

CROWN DERBY'S BLACK AVES

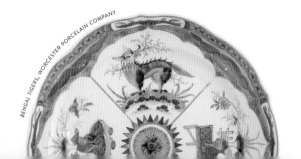

BENGAL TIGERS, WORCESTER PORCELAIN COMPANY

ENGRAVING OF A GIOVANNI BATTISTA CIPRANI PAINTING, PRINTED ON A PLATE

OVERLEAF: Minton oyster plate

ᴏERLEY CHINA COMPANY, CIRCA 1899

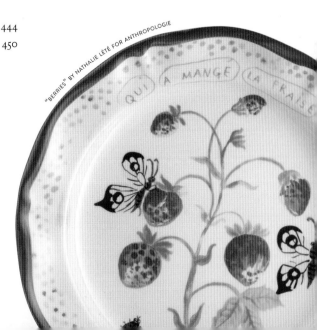

"BERRIES" BY NATHALIE LÉTÉ FOR ANTHROPOLOGIE

QUI A MANGE LA FRAISE

INTRODUCTION

PERHAPS YOU'RE SETTING OUT to get dishes just like your grandmother had. Or maybe you've just happened upon a piece that matches that blue-and-white transferware plate you already have at home. Or you might find yourself in a foreign flea market seduced by a table groaning under the weight of stacks of china in patterns, shapes, and colors you never noticed before. Whatever your design sensibilities, there are plates to fit them, and it's easy to get hooked once you start collecting. Whether of the finest porcelain or inexpensive melamine, plates bring design, color, and drama to the dining table—and allow hostesses and hosts to express their personal style.

For a long time diners at banquets did not get their own plate—two people seated next to each other would have to share. Only in the sixteenth century did etiquette rules decree a separate dish for everyone at the table. And the practice of utilizing the wide variety of specialized plates familiar to us today, especially at formal meals, only developed over the course of the eighteenth and nineteenth centuries. For a grand example, consider this: one set of dishes shipped from England to the United States in 1848 totaled 514 pieces, including twelve dozen (!) dinner plates—a service intended for entertaining on the grandest Gilded Age scale.

There are some eleven plate types you may encounter—though, admittedly, no one set would include all of these. The service plate, also known as a charger, 11 to 14 inches in diameter, is merely a decorative placeholder, set on the table until the food is served. Dinner plates measure 10 to 11 inches across, luncheon plates 9 to

9½ inches, a round salad plate 8 to 8½ inches (though you may see a crescent-shaped variant), and the bread-and-butter plate, which stays on the table throughout the meal, 6 to 7 inches. Though not so common today, fish plates, usually 8 to 9 inches in diameter, were made as a separate set, decorated, naturally, with fish or maritime motifs. Dessert plates, too, often come in a different design from the main service, and range from about 7¼ to 8½ inches across. The very well stocked china closet of a hundred years ago would also have included cheese plates (7¼ inches), tea plates (7 to 7½ inches), and fruit plates (6¼ to 8 inches). At lunches and less formal meals, you might come across a "fruit saucer," or side dish, which is deeper than a regular plate and is designed to hold juicy foods. These days, once common forms like oyster, escargot, asparagus, and bone plates are more likely to be found in antiques shops than on dinner tables.

SÈVRES "CAMEO" PORTRAIT PLATE, 1823

BLUE CANTON

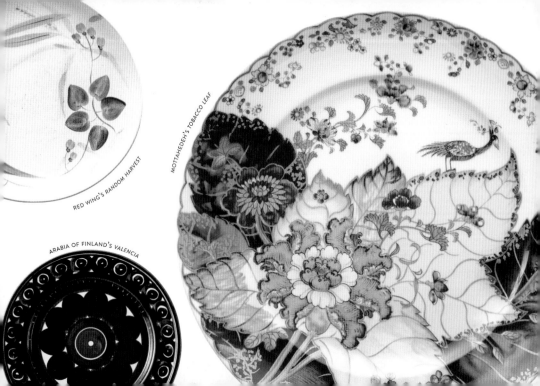

RED WING'S RANDOM HARVEST

MOTTAHEDEH'S TOBACCO LEAF

ARABIA OF FINLAND'S VALENCIA

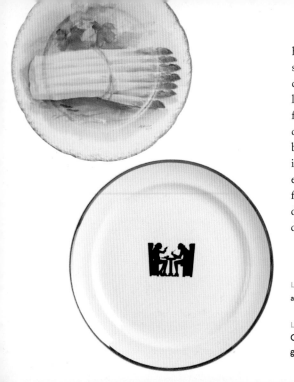

Over the last century, dining rituals and rules have grown ever more relaxed. The legions of servants needed to serve—and wash—so many dishes have vanished from most homes, and lengthy, aristocratic repasts are hardly the thing for a busy modern family. Although a meal these days is often more likely to be served in a cardboard container than on a porcelain plate, there is still a longing for beautiful dishes to serve and eat from whenever possible. In these pages, you'll find some of the best of the new alongside older designs that look as fresh, vivid, and bold as they did in the china shops of yore.

LEFT, ABOVE: One from a set of six hand-painted porcelain asparagus plates made in Limoges, France.

LEFT, BELOW: Embodying the spirit of the table, Hall China's *Silhouette* from the 1930s depicts two old-fashioned gentlemen enjoying a meal together.

ABOVE: English designer Clarice Cliff's "Biarritz" shape plate is a modern ceramic interpretation of the wooden trenchers used in the Middle Ages.

OVERLEAF: Plate with acid-etched gold and cobalt border from Cauldron, England, circa 1925.

A WARNING:
THIS BOOK MAY
INDUCE
CHINA-MANIA

A WEAKNESS FOR CHINA has long been a bit suspect. Beginning in the late 1600s, certain collectors were labeled as having the *maladie de porcelaine*, or porcelain sickness, an overweening desire to acquire more and more pieces of the precious material being imported from China. In 1692 Daniel Defoe criticized Queen Mary, coruler of England with her husband, William III, for the excessive amounts of porcelain with which she decorated every available surface in her rooms at Kensington Palace. In 1717 Saxon ruler Augustus II traded a regiment of six hundred soldiers for sixteen Chinese porcelain vases (and some other objects) with neighboring Prussia, causing worry among his subjects who were not similarly afflicted. In the opening scene of Edith Wharton's 1920 novel *The Age of Innocence,* the snobbish Lawrence Lefferts sums up the nasty character of Countess Olenska's estranged husband: "Well, I'll tell you the sort: When he wasn't with women he was collecting china. Paying any price for both, I understand."

Yes, the pursuit of old china can easily become an obsession. In his 1725 poem "To a Lady on Her Passion for Old China," John Gay declared "China's the passion of her soul; / A cup, a plate, a dish, a bowl / Can kindle wishes in her breast / Inflame with joy, or break her rest." Alice Morse Earle, author of the 1896 book *China Collecting in America,* called her annual china hunting expeditions a "midsummer madness" and spoke of the "fever" induced by stalking an elusive piece. When Sotheby's auctioned off Andy Warhol's estate in the spring of 1988, sophisticates were struck

dumb by the thousands of *Fiesta* ware and Russel Wright–designed dishes he had amassed.

These days, you're likely to be competing against a self-proclaimed "dish queen," either male or female, for that must-have piece of Stangl Kiddieware or World's Fair souvenir plate on eBay. So, take heed. In these pages, you're likely to see things you'll want to make your own. At the very least, you'll discover a new appreciation for the artistry of those dishes already stacked in your cupboard. And you'll probably soon find yourself in agreement with the English essayist Charles Lamb, who in 1823 admitted that when he visited great houses, he always asked to see the china closet first.

DISH QUEEN:
Defined in a 2005 *New York Times* story as "a person belonging to a rarefied and sometimes loopy group" who is hooked on buying dishes.

ABOVE: A plate from Eva Zeisel's *Town and Country* line, designed for Minnesota's Red Wing Pottery in 1945.

OPPOSITE: Floor-to-ceiling shelves laden with pieces of *Fiesta* ware at the North Carolina warehouse of Replacements, Ltd.

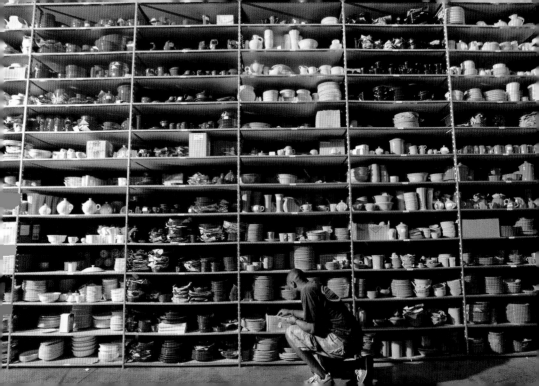

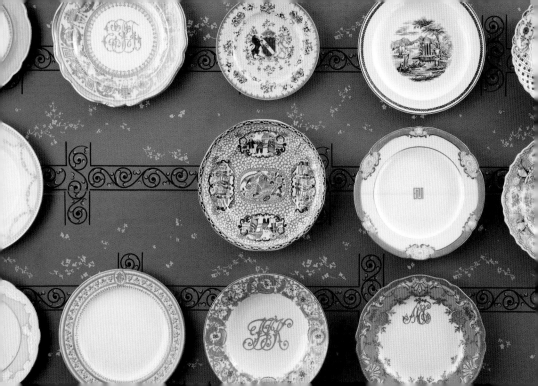

ELEGANCE & TRADITION

LONG AGO, THE FINEST DISHES were made of gold and silver. Nobility wouldn't eat off anything less, and royal tables were laden with them. Today fine porcelain reigns supreme in formal dishware, as it has for centuries. When Marco Polo returned to Venice in 1295 from his travels to the Far East, he brought ceramic dishes whose translucence and pure whiteness captivated viewers. He called it *porcella,* after its resemblance to a kind of delicate seashell, and Europeans were soon calling the rarity *porcelain.* With its distinctive blue and white color scheme, created by painting a design onto the white clay body with cobalt pigment to render a pattern under the outer layer of glaze, porcelain became one of the most coveted luxury items in the world.

Chinese design motifs, including pagodas, dragons, storks, peonies, lotus flowers, and chrysanthemums, were common in Europe during the ensuing centuries. And although the vast majority of porcelain imports were blue and white, Chinese and Japanese craftsmen were constantly experimenting with colored enamels and gilded details, and these early pieces still influence the way many of the finest dishes look today.

In the early eighteenth century, Europeans finally discovered the secret for making their own versions of true porcelain, and though they widely imitated Chinese designs at first, the wares from the royally sponsored factories at

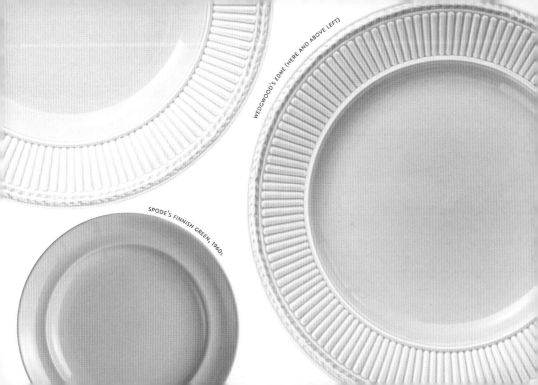

WEDGWOOD'S EDME (HERE AND ABOVE LEFT)

SPODE'S FINNISH GREEN, 1960s

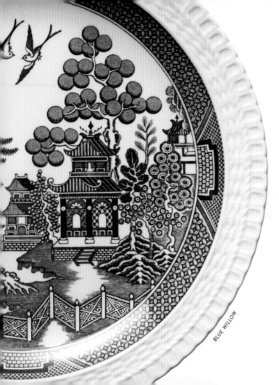

BLUE WILLOW

Meissen and Sèvres came to rival and surpass the Asian wares in terms of quality and decoration. At this time European flowers, landscapes, and other decorative motifs became more popular plate embellishments, too.

By the 1850s, a middle-class family's "everyday" dishes were probably earthenware from England, and their "good" china would likely have come from France. At the highest end, an exceptional china service for twelve from Sèvres could cost up to $500 (about $14,500 in today's dollars), while more common sets of earthenware from England or France could cost from $70 to $125 ($1,980 to $3,540 today). Whatever the material, a set of twelve place settings with an array of tureens, platters, gravy boats, and other serving dishes could easily number nearly two hundred pieces.

Even today, dishes can be a big investment. When a bride sets up house, choosing

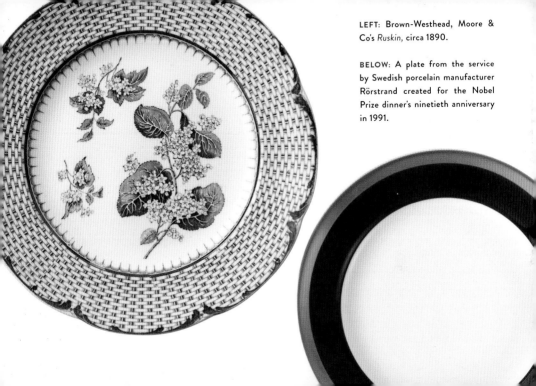

LEFT: Brown-Westhead, Moore & Co's *Ruskin*, circa 1890.

BELOW: A plate from the service by Swedish porcelain manufacturer Rörstrand created for the Nobel Prize dinner's ninetieth anniversary in 1991.

tableware—at least two sets, one for everyday use and a second for special occasions, according to many etiquette guides—has long been a rite of passage.

For most young households, however, the necessity of such large sets is questionable, which explains why so many of them sit unused in china cupboards to be handed down unscratched to the next generation. Even so, many who aspire to be a good hostess (or host) still seem to covet a set of new or heirloom painted and gilded dishes, the very embodiment of elegance and tradition.

ABOVE: On the best china, sometimes even the backs of plates got a little decoration—note the gilded foot ring on the bottom of this Spode piece.

OPPOSITE: French porcelain dessert plate with hand-painted gold initial, shaped rim, and elaborate gold scrolling overlay, circa 1860.

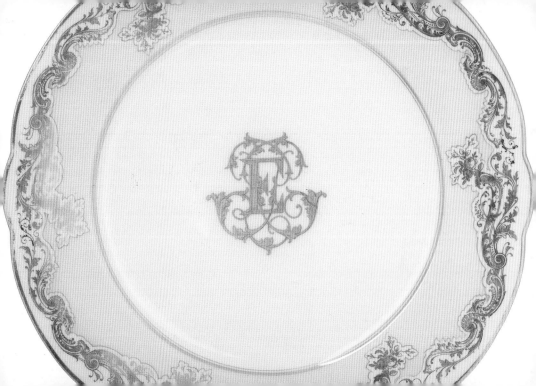

ASIAN INFLUENCES

The first porcelain in the Western world originated in the countries of the Far East, and for centuries no place on earth fired the West's imagination more.

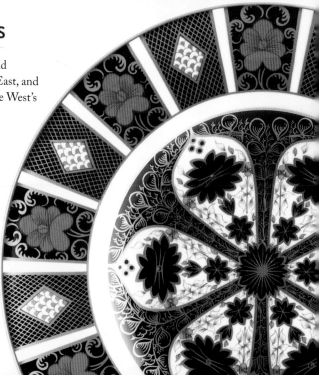

Long renowned for its interpretations of Oriental porcelains for the English and European markets, Royal Crown Derby issued *Old Imari* in 1901.

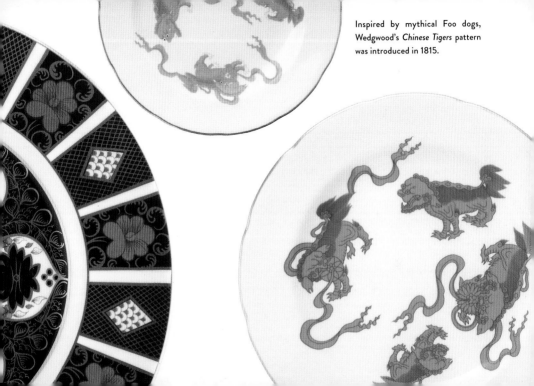

Inspired by mythical Foo dogs, Wedgwood's *Chinese Tigers* pattern was introduced in 1815.

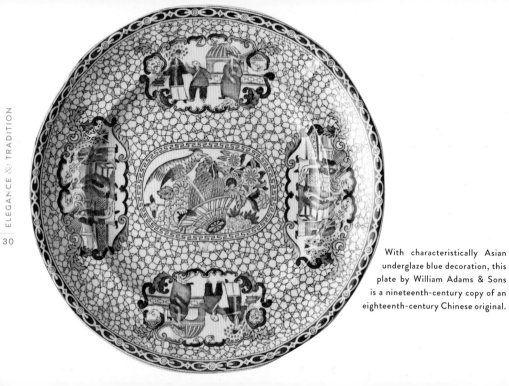

With characteristically Asian underglaze blue decoration, this plate by William Adams & Sons is a nineteenth-century copy of an eighteenth-century Chinese original.

England's Worcester Porcelain Company was known for its chinoiserie motifs in underglaze blue or enamel colors, as on this *Bengal Tigers* plate from about 1770.

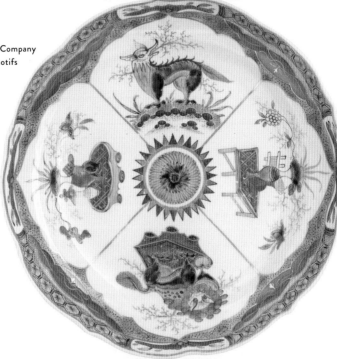

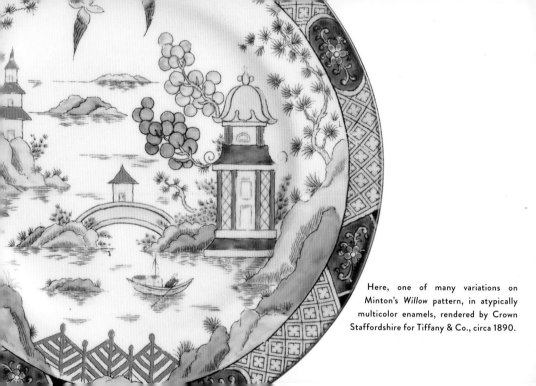

Here, one of many variations on Minton's *Willow* pattern, in atypically multicolor enamels, rendered by Crown Staffordshire for Tiffany & Co., circa 1890.

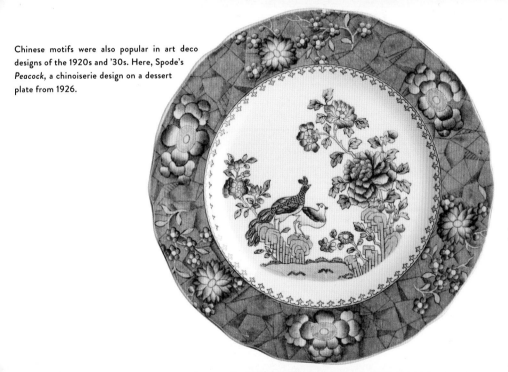

Chinese motifs were also popular in art deco designs of the 1920s and '30s. Here, Spode's *Peacock*, a chinoiserie design on a dessert plate from 1926.

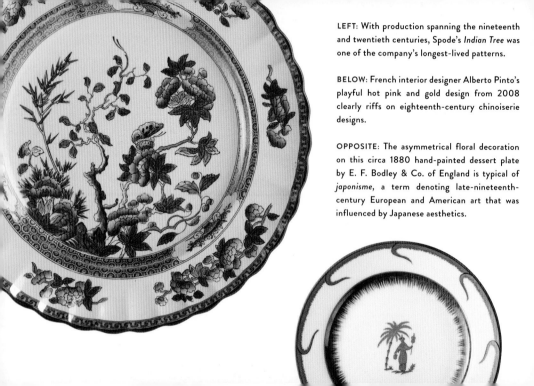

LEFT: With production spanning the nineteenth and twentieth centuries, Spode's *Indian Tree* was one of the company's longest-lived patterns.

BELOW: French interior designer Alberto Pinto's playful hot pink and gold design from 2008 clearly riffs on eighteenth-century chinoiserie designs.

OPPOSITE: The asymmetrical floral decoration on this circa 1880 hand-painted dessert plate by E. F. Bodley & Co. of England is typical of *japonisme*, a term denoting late-nineteenth-century European and American art that was influenced by Japanese aesthetics.

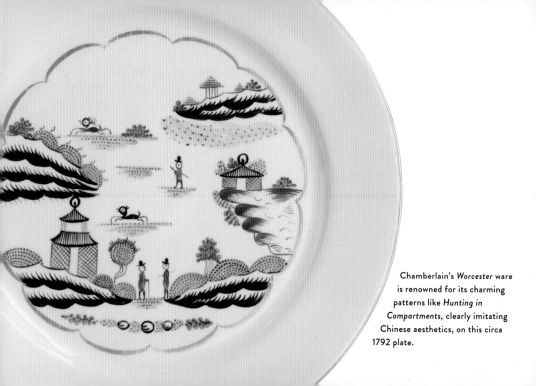

Chamberlain's *Worcester* ware is renowned for its charming patterns like *Hunting in Compartments*, clearly imitating Chinese aesthetics, on this circa 1792 plate.

European artists drew on Chinese gardens, architecture, and costumes to create whimsical fantasies of life in exotic Cathay, as on this hand-painted chinoiserie plate by Spode, circa 1810.

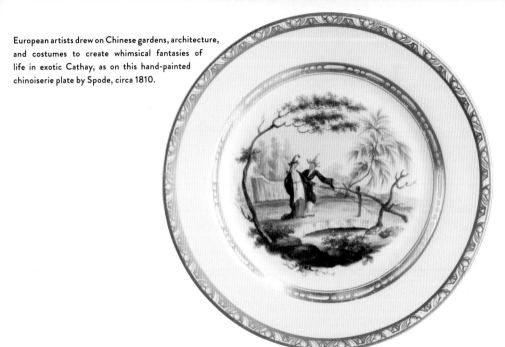

NEOCLASSICISM

The discoveries of the well-preserved Roman ruins of Herculaneum and Pompeii in the mid-eighteenth century ushered in a period of intense interest in the ancient world that has had an enduring impact on architecture, fashion, furniture, and, of course, tableware.

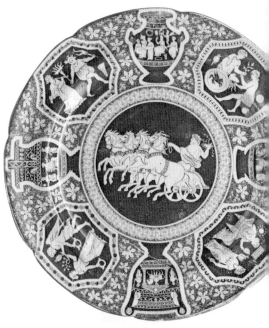

RIGHT: Spode's *Greek*, circa 1806, was not only fashionable, but also a marvel of early transfer-printing technique.

OPPOSITE: This earthenware plate from nineteenth-century Naples is in imitation of the so-called Etruscan (but really Greek) ceramics that were being manically dug up and passionately collected during the second half of the 1700s.

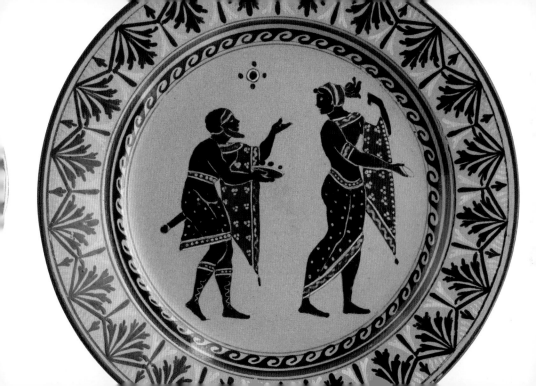

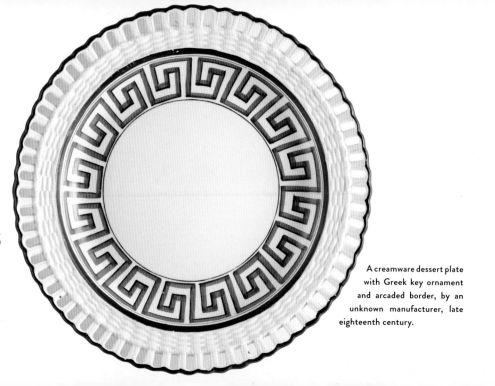

A creamware dessert plate
with Greek key ornament
and arcaded border, by an
unknown manufacturer, late
eighteenth century.

Spode dinner plate, circa 1923, with central urn motif in unusual pastel enamels.

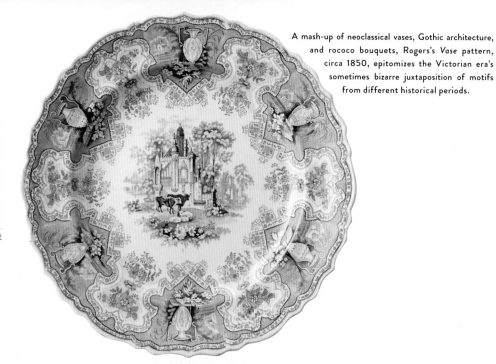

A mash-up of neoclassical vases, Gothic architecture, and rococo bouquets, Rogers's *Vase* pattern, circa 1850, epitomizes the Victorian era's sometimes bizarre juxtaposition of motifs from different historical periods.

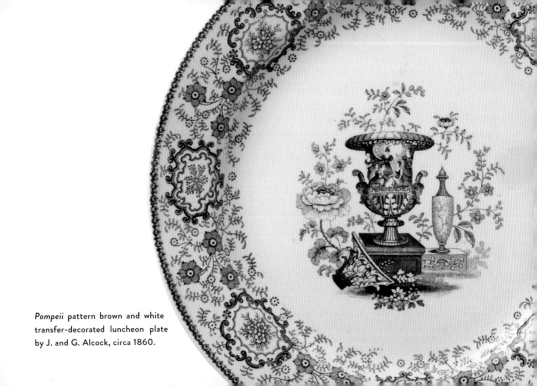

Pompeii pattern brown and white transfer-decorated luncheon plate by J. and G. Alcock, circa 1860.

CLASSIC WHITE

Faultlessly appropriate and elegantly austere, the white china plate is the little black dress of the dining table. Luckily, as with that ubiquitous black frock, designers past and present haven't been able to resist tweaking it.

Perfected in 1765, Wedgwood's creamware, here with "feather edge" rim, won over consumers—including England's Queen Charlotte, who reputedly had more than nine hundred pieces. In her honor, Wedgwood started calling it *Queen's Ware* in 1767.

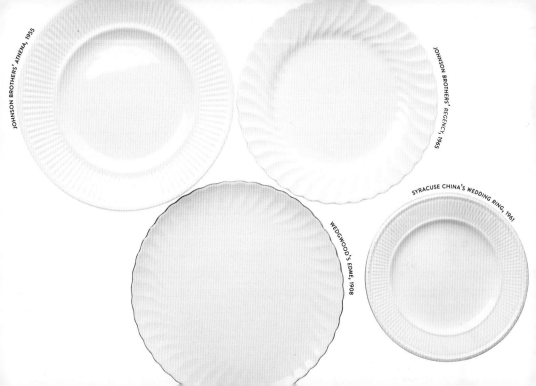

JOHNSON BROTHERS' ATHENA, 1955

JOHNSON BROTHERS' REGENCY, 1965

WEDGWOOD'S EDME, 1908

SYRACUSE CHINA'S WEDDING RING, 1961

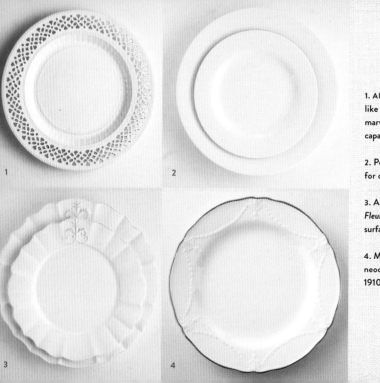

1. AND 5. Pierced-rim creamware dishes, like these circa 1780 examples, are marvels of eighteenth-century technical capabilities.

2. Pottery Barn's *PB White*, a best seller for decades.

3. Anthropologie's perennially popular *Fleur de Lys* has a distinctive chalky white surface.

4. Minton gold-rimmed salad plate with neoclassical swag relief decoration, circa 1910.

1

2

1. Jean-Marc Gady's *Gourmet Trio* (2008) is perfect for eaters who don't like to let their various foods touch on the same plate.

2. Ikuko Nakazawa's *Chat Plates* (2007) resemble the conversation bubbles in comic books.

3. Eva Zeisel's *Hallcraft* (aka *Tomorrow's Classic*) from 1952 for the Hall China Company came in pure white or emblazoned with decal ornaments ranging from the colorfully kitschy "Bouquet" to the abstractly modernist "Fantasy."

ART ON THE EDGE

From just a thin band of gold to intricate patterns of gold, platinum, and enamels, the elegant shape of fine white porcelain requires only the merest hint of decoration.

LEFT: Bold blue and delicate gold on an icy white body made by Coalport, circa 1900.

ABOVE: An unusual octagonal dinner plate with cobalt blue and a raised gold chain pattern on an ivory-colored body, from George Jones & Sons, circa 1920.

OPPOSITE: America's Lenox porcelain was known for the creamy hue of its clay. Layered salad, luncheon, and dinner plates, 1920s.

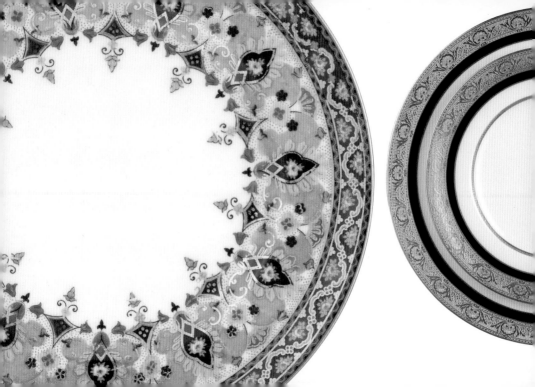

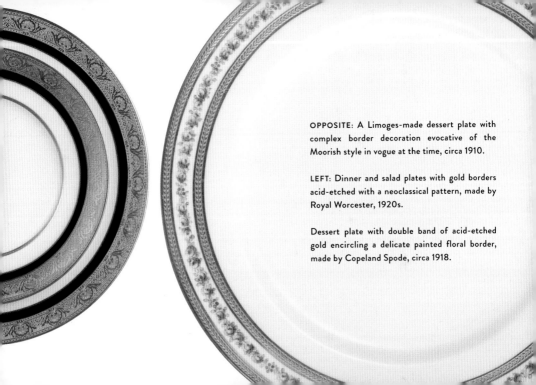

OPPOSITE: A Limoges-made dessert plate with complex border decoration evocative of the Moorish style in vogue at the time, circa 1910.

LEFT: Dinner and salad plates with gold borders acid-etched with a neoclassical pattern, made by Royal Worcester, 1920s.

Dessert plate with double band of acid-etched gold encircling a delicate painted floral border, made by Copeland Spode, circa 1918.

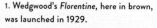

1. Wedgwood's *Florentine*, here in brown, was launched in 1929.

2. Noritake's *Colonnade*, introduced circa 1931.

3. Wedgwood *Queen's Ware* plate with hand-painted rim, 1820.

4. Wedgwood's *Harvest Festival* (aka *Persephone*) was launched in 1936 but became famous when it was used at the coronation banquet of Queen Elizabeth II in June 1953.

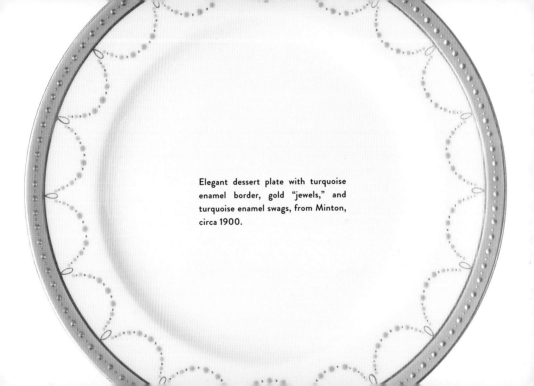

Elegant dessert plate with turquoise enamel border, gold "jewels," and turquoise enamel swags, from Minton, circa 1900.

By focusing on designs that required no hand-painting, such as 1930's *Apple Blossom*, here in coral, Lenox reduced its costs during the Great Depression.

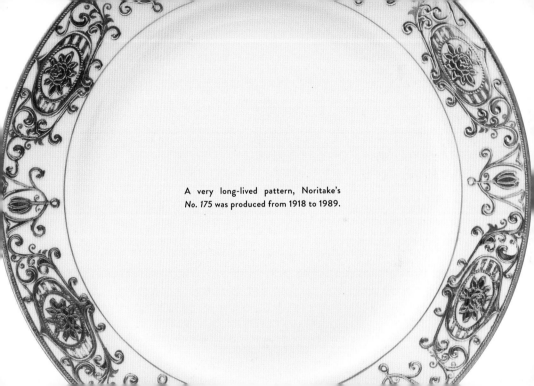

A very long-lived pattern, Noritake's
No. 175 was produced from 1918 to 1989.

MONOGRAMS

Whether it holds your family's coat of arms or a big, ornate initial, a personalized dish always makes a stylish statement.

RIGHT: Besides coats of arms, personal emblems also decorated plates. Here, an enigmatic image surrounded by the Latin motto AT SPES NON FRACTA (Hope is not crushed) on a Sèvres dessert plate, circa 1840.

OPPOSITE: In the seventeenth and eighteenth centuries, wealthy families would order sets of porcelain tableware from China emblazoned with their coats of arms. This plate is a nineteenth-century French imitation of such earlier "armorial china."

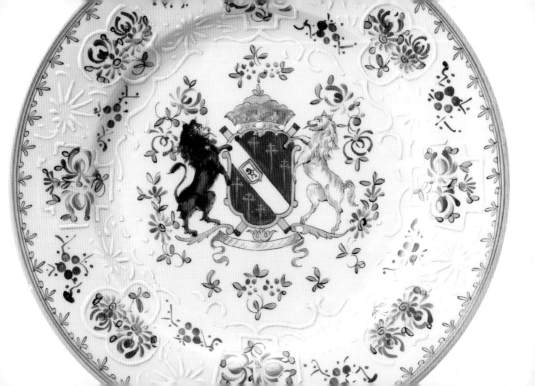

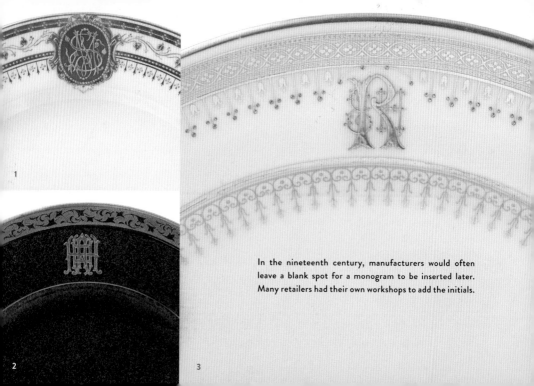

In the nineteenth century, manufacturers would often leave a blank spot for a monogram to be inserted later. Many retailers had their own workshops to add the initials.

1

2

3

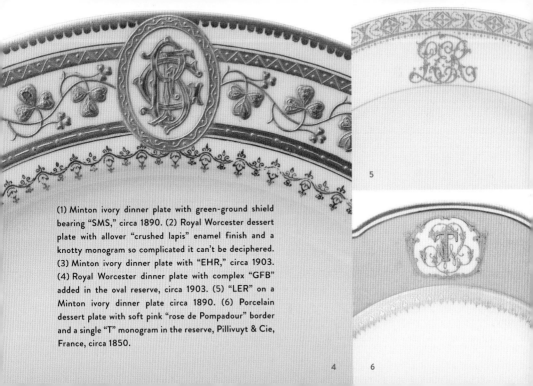

(1) Minton ivory dinner plate with green-ground shield bearing "SMS," circa 1890. (2) Royal Worcester dessert plate with allover "crushed lapis" enamel finish and a knotty monogram so complicated it can't be deciphered. (3) Minton ivory dinner plate with "EHR," circa 1903. (4) Royal Worcester dinner plate with complex "GFB" added in the oval reserve, circa 1903. (5) "LER" on a Minton ivory dinner plate circa 1890. (6) Porcelain dessert plate with soft pink "rose de Pompadour" border and a single "T" monogram in the reserve, Pillivuyt & Cie, France, circa 1850.

4

5

6

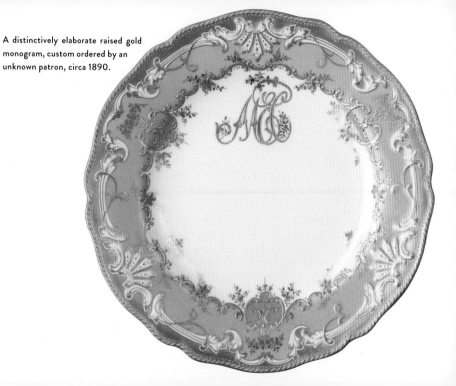

A distinctively elaborate raised gold monogram, custom ordered by an unknown patron, circa 1890.

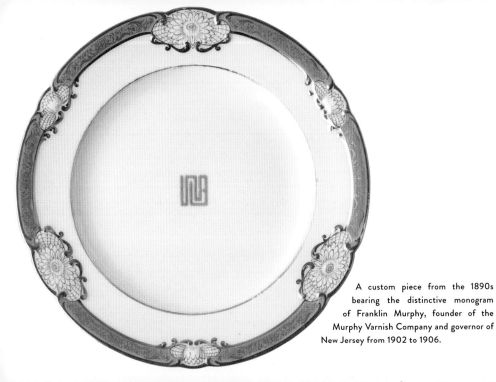

A custom piece from the 1890s bearing the distinctive monogram of Franklin Murphy, founder of the Murphy Varnish Company and governor of New Jersey from 1902 to 1906.

1. Handblown crystal dessert plate with sterling silver overlay and border, circa 1910.

2. While this dessert plate with shaped rims was manufactured by Spode, the gold art nouveau decoration was added later by a freelance artist, circa 1905.

3. A modernist contrast to the frilly monograms of the nineteenth century, *Urania*, a 1938 design for KPM in Berlin, carries an initial in the sober capitals of the Bodoni typeface.

2

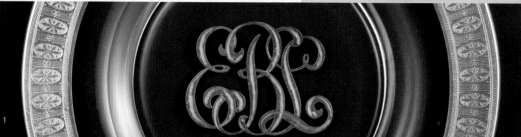

1

M

TEN PATTERNS THAT HAVE STOOD THE TEST OF TIME

1. The café au lait hue of Wedgwood's *Drabware*, the natural color of the clay body itself, has seduced tastemakers since 1811.

2. Villeroy & Boch's *Vieux Luxembourg* was first produced in 1768 and reintroduced in 1970.

3. A 2002 Spode plate featuring the iconic *Willow* pattern, first engraved by Thomas Minton in 1790.

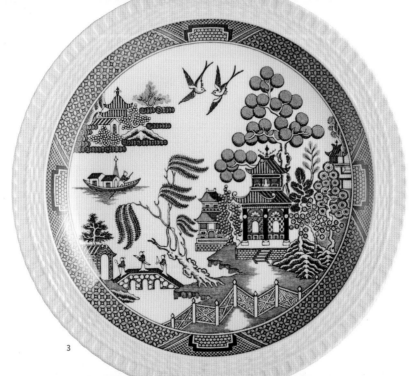

3

4. Spode's *Italian Scene*, sometimes called *Blue Italian*, was so popular that the original copperplates wore out; new ones were engraved in 1944.

5. Royal Copenhagen's *Blue Fluted Lace*, introduced in about 1775.

6. Meissen's *Blue Onion* pattern, copied from a Chinese bowl depicting pomegranates (a fruit unknown in Germany at the time, hence the misnomer) has been in production since 1739.

7. Decidedly more humble than porcelain, classic green-band-decorated vitreous china has been made by many American manufacturers for decades.

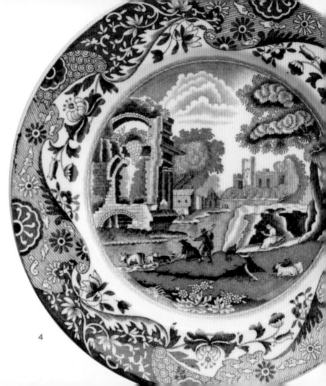

4

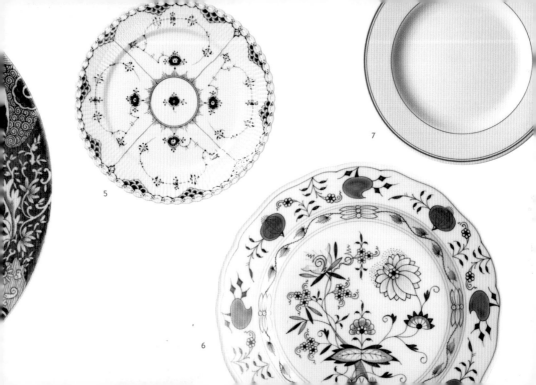

5

6

7

8. Meissen's *Ming Dragon* was first painted in 1745. The dragon, an ancient and potent symbol in Chinese art, was reserved for the exclusive use of the emperor and his sons.

9. In 1790 the Danish prince ordered a dinner set decorated with images from the *Flora Danica*, a botanical record of the native plants of Denmark. It is still pulled out for state dinners.

10. First designed in 1901, these stoneware plates from the Wiener Werkstätte (Vienna Workshop) are classics of modernist design still available for purchase.

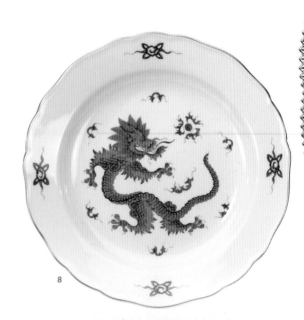

8

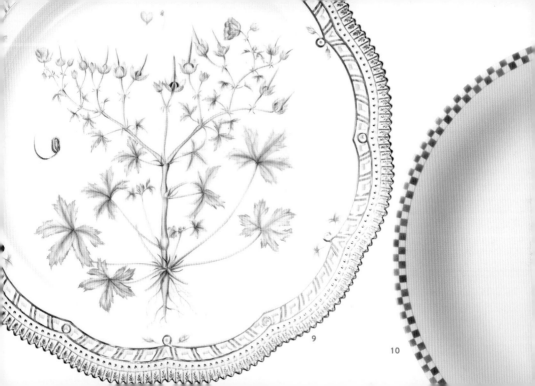

9 10

MEISSEN, SÈVRES, AND LIMOGES

Founded in 1710 by Augustus the Strong of Saxony, Meissen was the first manufacturer of true porcelain in Europe. Their wares were so valuable that they were called "white gold." From 1720 the chief painter, J. G. Höroldt, perfected a number of new enamel colors and ushered in a period of extremely sophisticated painted decoration on porcelain's plain white surface.

By the 1760s, Sèvres had usurped Meissen's fashion lead. Louis XV took an interest in the fledgling porcelain manufactory in 1752, investing money, bestowing the title "Manufacture Royale de Porcelaine," and staging an annual sale of its products in his private dining room at Versailles. (Courtiers were expected to make purchases if they wanted to get in good with the king.) Though the factory went through a difficult period during the French Revolution, it achieved new heights during the reign of Napoleon.

When the key minerals required for the production of true porcelain, unlike the so-called soft-paste porcelain being created by Sèvres, were discovered near the town of Limoges in France in 1768, it became France's center of porcelain production, and the town's name became a byword for elegant French tableware. Haviland & Co. (founded in 1842) and Bernardaud (founded in 1900) are just two of the most famous manufacturers based there.

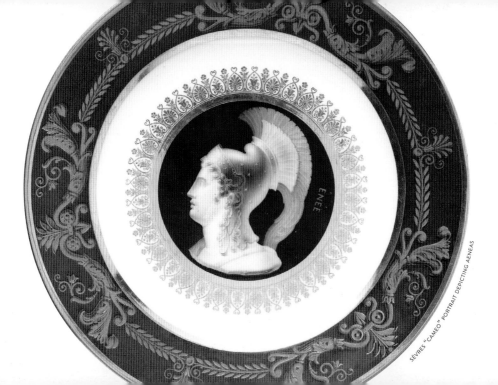

SÈVRES "CAMEO" PORTRAIT DEPICTING AENEAS

ENEÉ

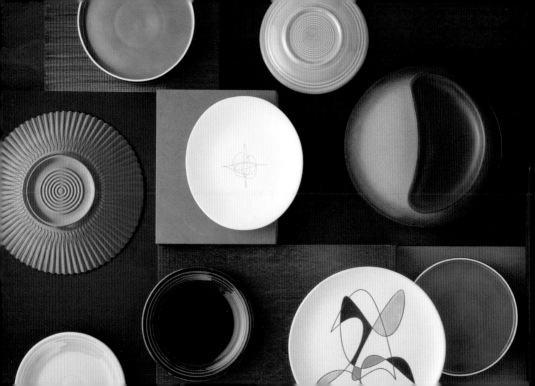

COLOR & FORM

OVER THE COURSE of the twentieth century, as dining habits became less formal, much fine china crossed the line from being functional to being purely decorative. Modern consumers wanted dishes that fit into a more relaxed lifestyle. To keep up with the demand, companies invested in technological research and hired famous industrial designers like Raymond Loewy, Russel Wright, and Eva Zeisel to come up with innovations in patterns, shapes, and materials that reflected modern ways of dining and entertaining.

One of the most obvious trends was the introduction of durable earthenware pieces colored with new, intense chemical glazes. In the early twentieth century, the inexpensive products of California-based manufacturers like J. A. Bauer Pottery, Pacific Clay Products, and Gladding McBean came to epitomize the American way of eating. Such "California colored pottery" was so successful that many eastern manufacturers started making their own versions, most notably *Fiesta,* introduced in 1936 by the Homer Laughlin China Company of Newell, West Virginia, which would go on to eclipse them all in popularity. As a 1938 ad for the line put it, "Fiesta dinnerware has blazed across the country in a gay blaze of color. Its beautiful rainbow shades have captivated the hearts of housewives." American hostesses responded wholeheartedly to the ability to mix and match colors on the table, and the line continues to be a best seller today.

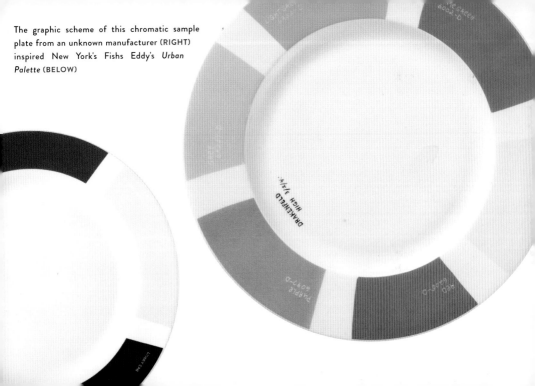

The graphic scheme of this chromatic sample plate from an unknown manufacturer (RIGHT) inspired New York's Fishs Eddy's *Urban Palette* (BELOW)

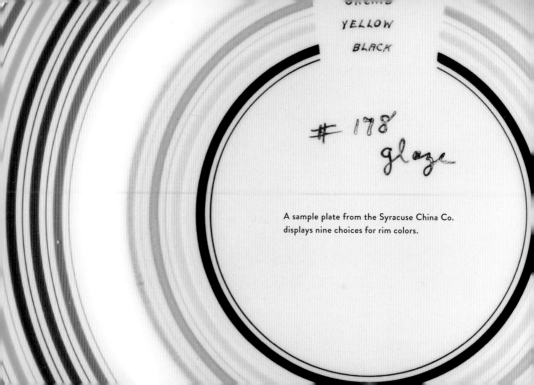

ORCHID

YELLOW

BLACK

178
glaze

A sample plate from the Syracuse China Co.
displays nine choices for rim colors.

Manufacturers also experimented with new materials and manufacturing techniques. The introduction of the semiautomatic feeder into glass factories in 1917 enabled the explosion in cheap pressed-glass tableware, now known as Depression glass, which flooded the market in the 1920s and '30s. By the 1950s, a type of plastic called melamine had become so popular that old-line manufacturers like the Lenox and Stetson china companies and Fostoria Glass started their own plastics divisions. In 1970 Corning introduced its extremely light, elegantly thin, and nearly indestructible Corelle line of tableware, made by laminating three layers of tempered glass. And, of course, there was paper. Although a February 1885 article in *Ladies' Home Journal* touted paper plates that "were so cheap they could be thrown away after once using," it wasn't until the post–World War II years that disposable tableware really took off.

No matter what the material, however, manufacturers over the past century have constantly sought

improvements. Factories introduced oven-to-table ware and eventually microwave-proof pieces. They searched for ways to make dishes impervious to the corrosive effects of strong detergents and high temperatures in dishwashing machines. To test the durability of the new, and hopefully improved, glazes, the A. J. Wahl Company of Brocton, New York, which made machinery for the ceramics industry, even patented a "scratch resistance tester," which companies could use to see just how many scrapes of a knife it would take to break through the layer of glaze, thus protecting the colored finishes.

Who knew the humble plate could inspire so much innovation beyond mere surface decoration? And yet it still does. In 2003 Rachel Speth and Jeff Delkin founded Bambu and introduced their Veneerware single-use bamboo plates as an organic, more environmentally sustainable competitor to paper and plastic disposables.

ARTIST TED MUEHLING'S DESIGN FOR NYMPHENBURG

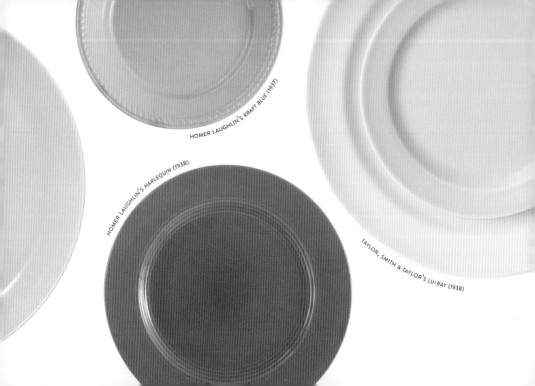

HOMER LAUGHLIN'S KRAFT BLUE (1937)

HOMER LAUGHLIN'S HARLEQUIN (1938)

TAYLOR, SMITH & TAYLOR'S LU-RAY (1938)

FLOW BLUE

The smeary effect on Flow Blue pieces results from the cobalt pigment running during firing in the kiln. While this manufacturing flaw rendered the pieces unmarketable in England, the plates were big sellers across the Atlantic from the mid-1820s onward.

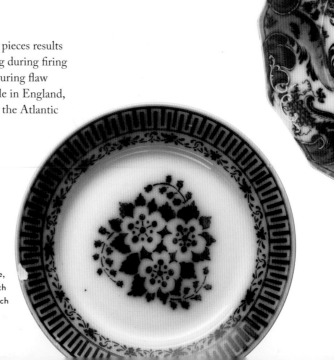

This artfully smudged Flow Blue plate, probably dating from the late nineteenth century, is an unusual example of a French factory imitating an English style.

ABOVE: Tunstall, England's W. H. Grindley & Co., which was in business from 1880 to 1991, is one of the best-known manufacturers of Flow Blue wares made for export to North and South America and Australia. Their *Argyle* pattern was introduced in 1896.

RIGHT: Johnson Brothers' *Blue Danube* dates from 1912.

EARLY INNOVATIONS

Long before the invention of plastic and
paper dishes, manufacturers looked for
ways to make plates more modern.

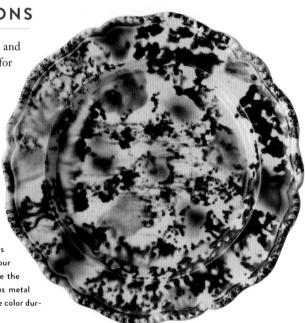

Tortoiseshell ware enjoyed a brief vogue in
the middle of the eighteenth century, and
pieces such as these circa 1760 examples
by Thomas Whieldon sold for as much as four
times the price of plainer versions. To create the
distinctive mottling, potters sponged various metal
oxides onto the clay body, which would create color dur-
ing firing; no two pieces are the same.

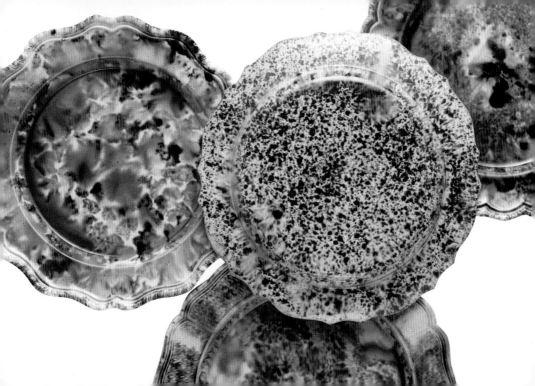

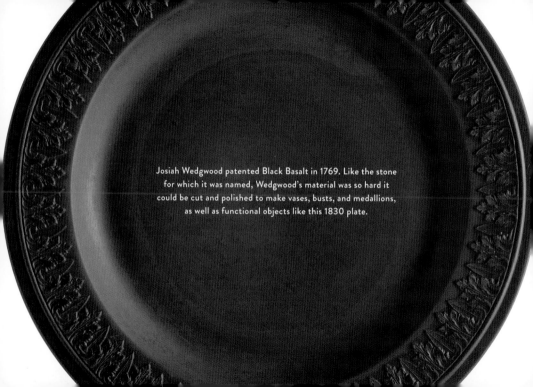

Josiah Wedgwood patented Black Basalt in 1769. Like the stone for which it was named, Wedgwood's material was so hard it could be cut and polished to make vases, busts, and medallions, as well as functional objects like this 1830 plate.

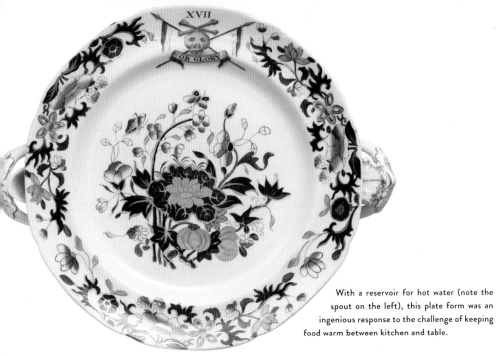

With a reservoir for hot water (note the spout on the left), this plate form was an ingenious response to the challenge of keeping food warm between kitchen and table.

BRINGING COLOR TO THE TABLE

"Color! That's the trend today," declared an early brochure for *Fiesta,* one of the most successful patterns of all time. It was launched in 1936, and some eighty years later, new colors are still introduced on a regular basis.

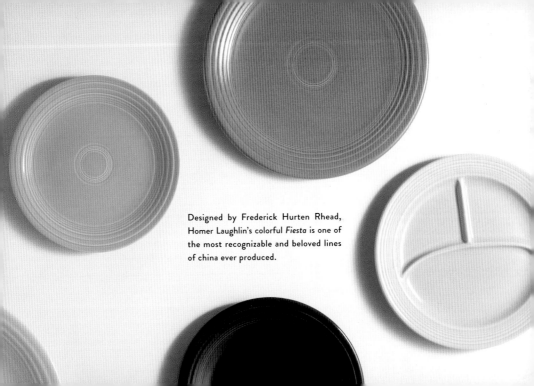

Designed by Frederick Hurten Rhead, Homer Laughlin's colorful *Fiesta* is one of the most recognizable and beloved lines of china ever produced.

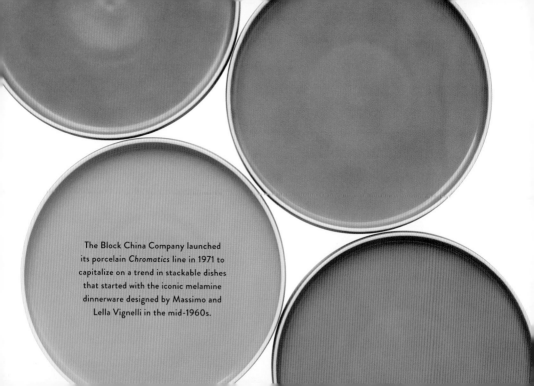

The Block China Company launched
its porcelain *Chromatics* line in 1971 to
capitalize on a trend in stackable dishes
that started with the iconic melamine
dinnerware designed by Massimo and
Lella Vignelli in the mid-1960s.

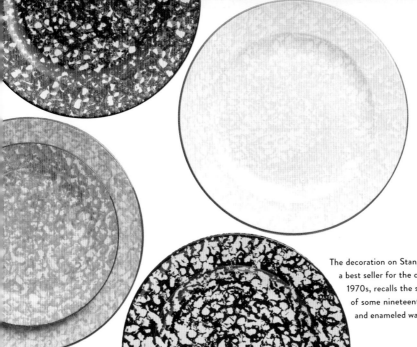

The decoration on Stangl's *Town & Country*, a best seller for the company in the mid-1970s, recalls the sponged-on patterns of some nineteenth-century ceramics and enameled wares.

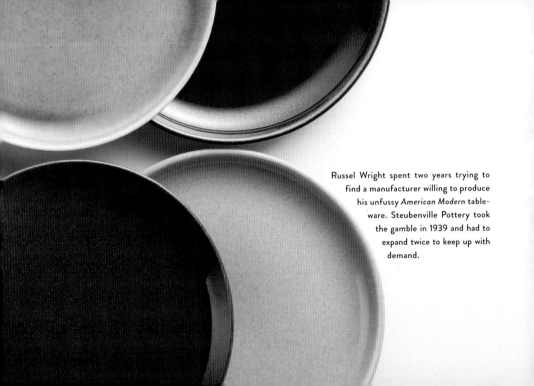

Russel Wright spent two years trying to find a manufacturer willing to produce his unfussy *American Modern* tableware. Steubenville Pottery took the gamble in 1939 and had to expand twice to keep up with demand.

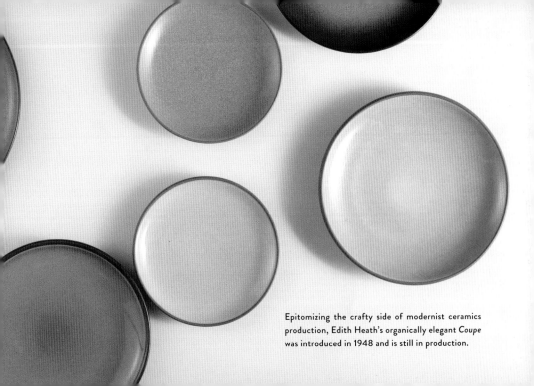

Epitomizing the crafty side of modernist ceramics production, Edith Heath's organically elegant *Coupe* was introduced in 1948 and is still in production.

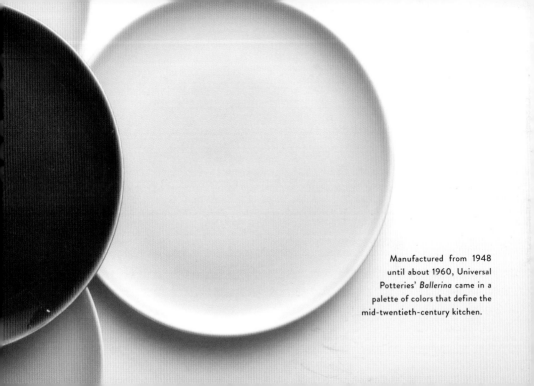

Manufactured from 1948 until about 1960, Universal Potteries' *Ballerina* came in a palette of colors that define the mid-twentieth-century kitchen.

The colors of Johnson Brothers' *Dawn* lines,
made between 1925 and 1970, come from the
clay body itself rather than by application of a
glaze coating only the surface. If a plate chips, you
will see the same hue throughout.

T. G. Green's *Cornishware* has been a common sight in U.K. kitchens since the 1920s. The origin of the simple, bold design is unknown, but a 1938 company pamphlet poetically described it as the "Blue of the Atlantic" and the "White of the Cornish Clouds."

GLASS

At the beginning of the twentieth century, glassware became so cheap to produce that it was often given away, and there's still so much of it that it's rather easy to amass a nice collection.

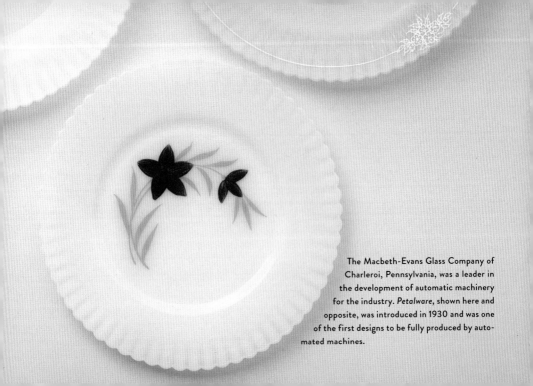

The Macbeth-Evans Glass Company of Charleroi, Pennsylvania, was a leader in the development of automatic machinery for the industry. *Petalware*, shown here and opposite, was introduced in 1930 and was one of the first designs to be fully produced by auto-mated machines.

The delicately hand-etched ornament on
this unmarked yellow salad plate signals
a piece from the nineteenth century,
before glass factories were outfitted for
automated production.

From 1940 to 1970, Anchor Hocking
Glass Corporation's *Fire King* glassware
was lauded as a "miracle" of technology
because it was heatproof and could go from
oven to table. Pieces in Jadeite, seen here,
are hugely collectible today, especially after
Martha Stewart revealed her love for the color
of these wares in the 1990s.

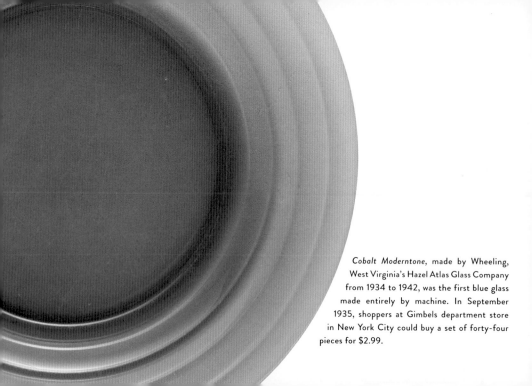

Cobalt Moderntone, made by Wheeling, West Virginia's Hazel Atlas Glass Company from 1934 to 1942, was the first blue glass made entirely by machine. In September 1935, shoppers at Gimbels department store in New York City could buy a set of forty-four pieces for $2.99.

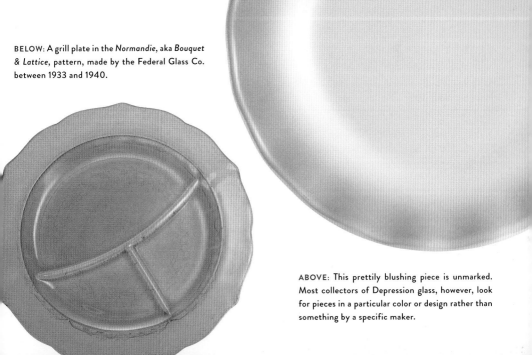

BELOW: A grill plate in the *Normandie*, aka *Bouquet & Lattice*, pattern, made by the Federal Glass Co. between 1933 and 1940.

ABOVE: This prettily blushing piece is unmarked. Most collectors of Depression glass, however, look for pieces in a particular color or design rather than something by a specific maker.

TRENDY TABLES

Over the course of the twentieth century, manufacturers labored to convince hostesses that they should have separate dishes for every meal, and that dishes could be replaced as easily as clothing to reflect changing fashions. Many of these short-lived patterns are highly collectible today.

RIGHT: Metlox Pottery's *California Mobile* (1954) calls to mind the animated sculptures of Alexander Calder.

OPPOSITE: The Edwin M. Knowles China Co. launched the *Pacific Plaids* collection, designed by Virginia Hamill, in about 1950. The nine patterns were each named after a city in the western United States. Here, "Las Vegas."

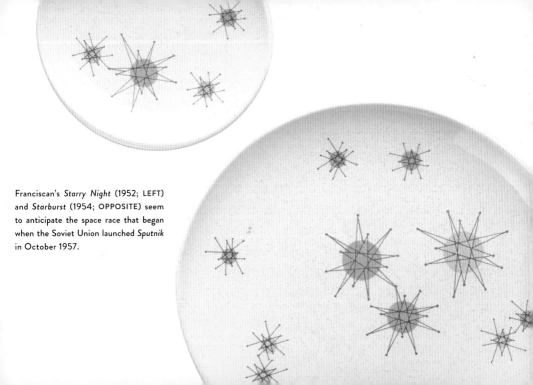

Franciscan's *Starry Night* (1952; LEFT) and *Starburst* (1954; OPPOSITE) seem to anticipate the space race that began when the Soviet Union launched *Sputnik* in October 1957.

Produced for just a few years in the mid-1970s, Mikasa's *Country Gingham* evokes the down-home textile. It was one of the first plates to indicate that it was, as marked on the reverse, SAFE IN MICROWAVE OVENS.

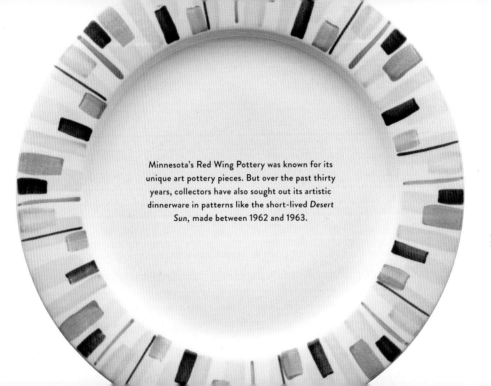

Minnesota's Red Wing Pottery was known for its unique art pottery pieces. But over the past thirty years, collectors have also sought out its artistic dinnerware in patterns like the short-lived *Desert Sun*, made between 1962 and 1963.

FASHION PLATES

If you're a fashionista at heart, there's definitely a line that will allow your table to be as well dressed as you are.

The vintage styles and Asian aesthetics that Georgina Chapman and Keren Craig, the designers behind Marchesa, draw upon for their evening wear are also seen in their romantic dinnerware collection for Lenox.

Ralph Lauren's *Whipstitch*, for the
Lauren Home line, is a subtle evocation
of rugged Old West style.

The subtle simplicity of her tabletop
collection for Lenox embodies
Donna Karan's global Zen-organic
approach to design. Here, one of her
Matte & Shine dinner plates.

Vera Wang's collaboration with
Wedgwood often takes inspiration
from the decorative touches used
on wedding gowns. The rims of
Grosgrain mimic ribbon.

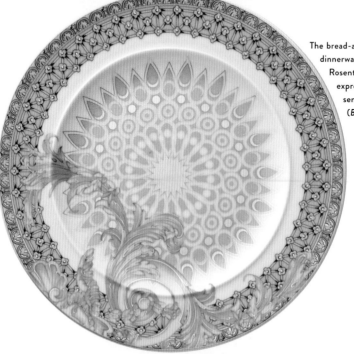

The bread-and-butter plates of the Versace dinnerware collection, manufactured by Rosenthal China, are perfectly baroque expressions of the company's design sensibility brought to the table. (*Byzantine Dreams*, pictured here.)

Diane von Furstenberg brings her bold way with color and pattern to dishes, and the result, as in *Sun Stripe*, is *très très chic*.

If you like Kate Spade's oh-so-girlish bags and accessories, check out her playful yet elegant dishes for Lenox, such as *Larabee Road*, shown here.

Calvin Klein clothing has long been known for its
way with textures and neutrals. The house brings
its luxurious take on minimalism to the table with
the all-white but not-at-all boring *Mollusk*.

THE HOMER LAUGHLIN CHINA COMPANY

The seeds for today's best-selling *Fiesta* ware were planted more than a century ago, when Homer and Shakespeare Laughlin established the Ohio Valley Pottery in East Liverpool, Ohio, in about 1873. Although Shakespeare left the company in 1877, Homer Laughlin held on until 1897, when he retired and sold the business to W. Edwin Wells, who had been the company's bookkeeper, and Louis I. Aaron and his sons. Within a few years, the new owners were running three factories in East Liverpool and had opened a plant across the river in Newell, West Virginia. By 1916, 40 percent of the factory's wares were sold though the dime-store chain Woolworth's, with which the company collaborated closely on product design.

In 1927 English designer Frederick Hurten Rhead became the company's art director. Rhead created the enormously successful *Fiesta* in 1936 (see page 88), and the similarly styled but cheaper *Harlequin* line (right), exclusively for Woolworth's, in 1938. By the 1950s, the company was focusing on its range of commercial wares for restaurants and hotels. They reentered the consumer market with great fanfare when they relaunched the *Fiesta* line (dormant since 1972) in 1986. In 2002, after five generations of partnership, the Wells family took over the Aaron family's stake in the business.

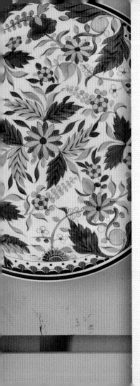

ART & CRAFT

SHARDS OF POTTERY SURVIVE from the earliest moments when our human ancestors stopped merely hunting and gathering and settled into an agrarian lifestyle. Since clay is found all over the world and it doesn't take much skill to mold it into useful shapes and let it dry in the sun, crockery developed as potters experimented with the interaction of their materials and heat. Once the basic technology was established, potters began distinguishing their wares with artistry, pushing the envelope of sculptural form and creating sophisticated surface treatments. The earliest designs were simple patterns incised into the hardening clay. Later innovations included painted-on decoration and the application of glazes that were both aesthetically pleasing and functional (objects made of porous earthenware require a coat of glaze if they are to hold liquids).

In Renaissance Italy, artisans discovered that coating the dark earthenware body in an allover tin glaze that turns white during kiln firing created the perfect blank canvas upon which painters could execute all sorts of designs. At first painters were satisfied with simple geometric patterns and stylized depictions of flowers and animals. However, from about 1500 the *istoriato* style, literally "story painting," took hold. Plates began to bear colorfully rendered stories from mythology and history and copies of works by Raphael and other great artists. Many

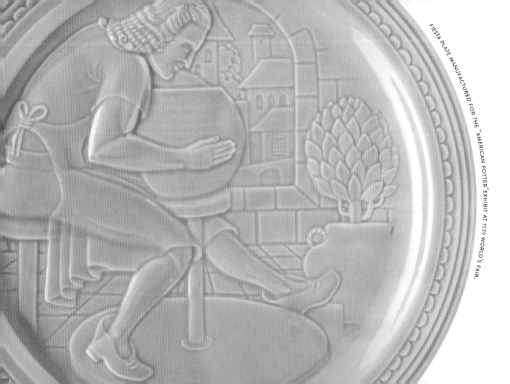

ART & CRAFT

125

maiolica painters would sign or initial their works, too, an indication of the pride they took in the production. The best pieces were sought after by the grandest patrons of the period—and can be found in museums today.

World-famous artists, including Paul Gauguin, Claude Monet, Henri Matisse, Pablo Picasso, Roy Lichtenstein, Alexander Calder, and Cindy Sherman, have been attracted to the plate as a canvas for expressing their ideas. Architects like A. W. N. Pugin, Frank Lloyd Wright, and Robert Venturi have also designed dishes. Recently, two contemporary companies, The New English in Stoke-on-Trent, England, and Ink Dish in San Diego, California, have turned to artists—including tattoo designers—to breathe new life into manufactured tableware.

Plates are made by craftspeople—potters, most obviously, but also woodturners, metalworkers, and glass molders. All are artisans but

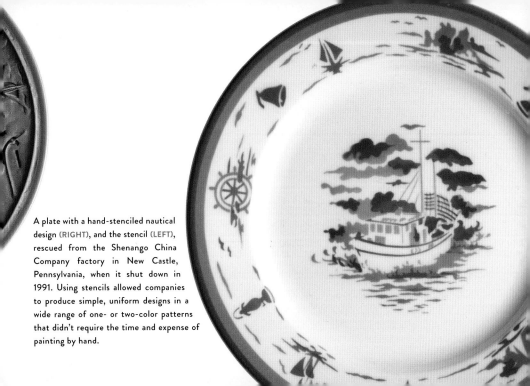

A plate with a hand-stenciled nautical design (RIGHT), and the stencil (LEFT), rescued from the Shenango China Company factory in New Castle, Pennsylvania, when it shut down in 1991. Using stencils allowed companies to produce simple, uniform designs in a wide range of one- or two-color patterns that didn't require the time and expense of painting by hand.

not usually considered fine artists. However, their products are indeed works of art. In the final fitting irony, consider then how plates themselves finally become the canvases of those other artisans of sustenance: cooks and chefs. All the arts of the table combine to raise the necessary act of eating to the highest artistic pleasure, and it all starts on the plate.

"VARIATION #1," A "REMIX" OF ROYAL COPENHAGEN'S CLASSIC BLUE FLUTED LACE BY KAREN KJOELDGÅRD-LARSEN

JUGTOWN POTTERY'S CORNWALL STONE

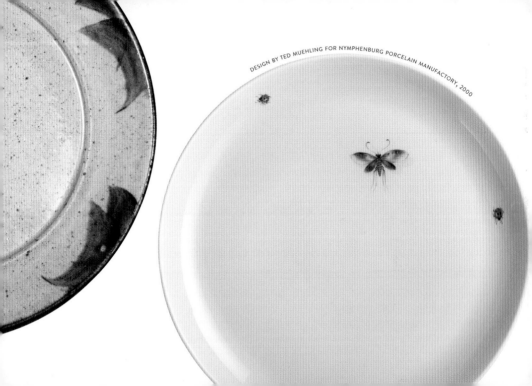

DESIGN BY TED MUEHLING FOR NYMPHENBURG PORCELAIN MANUFACTORY, 2000

TIN-GLAZED EARTHENWARE

Tin-glazed earthenware goes by many names: *maiolica* in Italy, *faience* in France, and *Delftware* in the Netherlands and England. Many of the historical centers of production still support craftspeople who churn out pieces utilizing methods and motifs developed centuries ago.

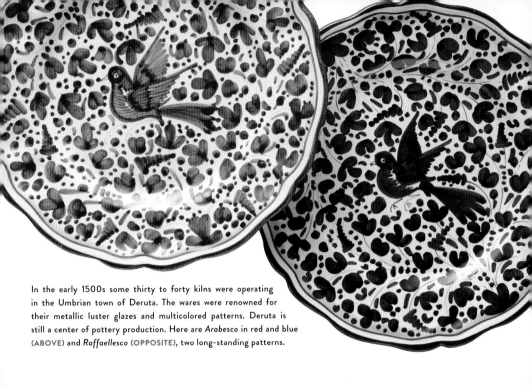

In the early 1500s some thirty to forty kilns were operating in the Umbrian town of Deruta. The wares were renowned for their metallic luster glazes and multicolored patterns. Deruta is still a center of pottery production. Here are *Arabesco* in red and blue (ABOVE) and *Raffaellesco* (OPPOSITE), two long-standing patterns.

Over the course of the seventeenth century, as
demand for Chinese wares outstripped supply,
Delft became a center for the production
of ceramics imitating the styles of Asian
porcelain, as in this Dutch Delftware
pancake plate, circa 1780.

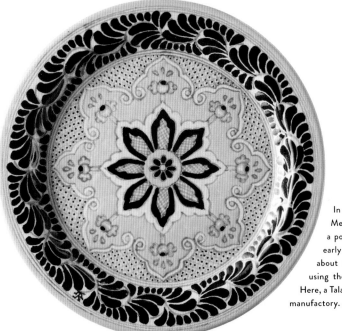

In an effort to bring industry to Mexico, Jesuit missionaries established a pottery in the town of Pueblo in the early sixteenth century. There are still about seventeen certified manufacturers using the old methods in the town today. Here, a Talavera Poblana plate from the Uriarte manufactory.

FOLK TRADITIONS

Carved, cast, potted, or painted, a plate
can be the ultimate piece of folk art.

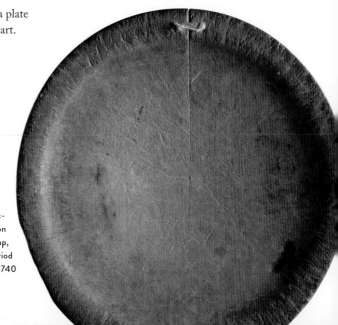

Treenwares—carved or turned-wood func-
tional objects—were the most common
dishes before the introduction of cheap,
mass-produced ceramics. Note the period
string repair at the crack on this circa 1740
trencher from New England.

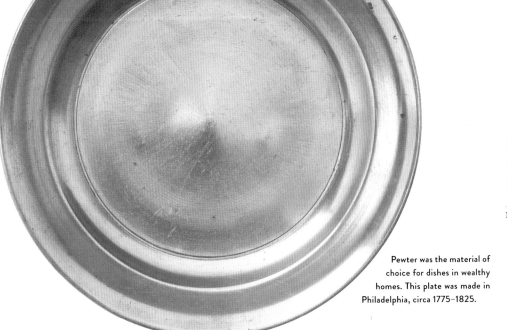

Pewter was the material of
choice for dishes in wealthy
homes. This plate was made in
Philadelphia, circa 1775–1825.

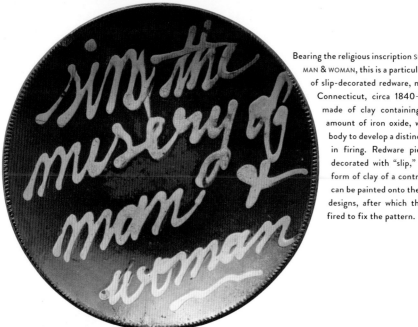

Bearing the religious inscription SINS, THE MISERY OF MAN & WOMAN, this is a particularly rare example of slip-decorated redware, made in Norwalk, Connecticut, circa 1840–50. Redware is made of clay containing a considerable amount of iron oxide, which causes the body to develop a distinctive reddish cast in firing. Redware pieces were often decorated with "slip," a watered-down form of clay of a contrasting color that can be painted onto the surface to make designs, after which the piece is again fired to fix the pattern.

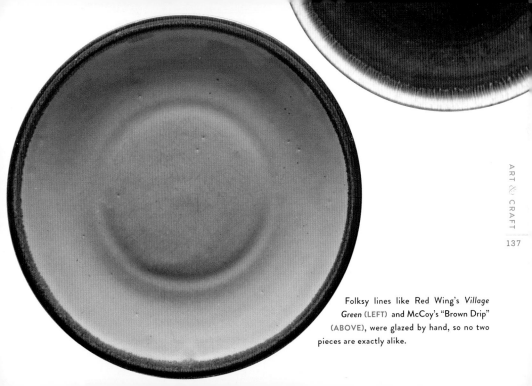

Folksy lines like Red Wing's *Village Green* (LEFT) and McCoy's "Brown Drip" (ABOVE), were glazed by hand, so no two pieces are exactly alike.

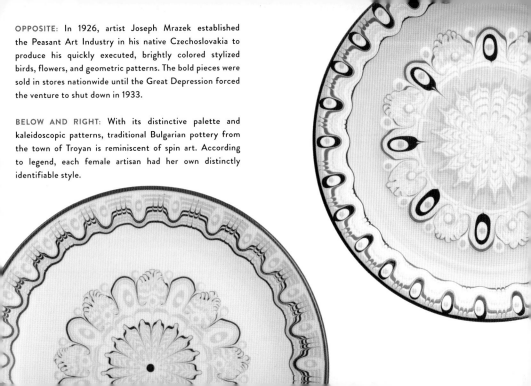

OPPOSITE: In 1926, artist Joseph Mrazek established the Peasant Art Industry in his native Czechoslovakia to produce his quickly executed, brightly colored stylized birds, flowers, and geometric patterns. The bold pieces were sold in stores nationwide until the Great Depression forced the venture to shut down in 1933.

BELOW AND RIGHT: With its distinctive palette and kaleidoscopic patterns, traditional Bulgarian pottery from the town of Troyan is reminiscent of spin art. According to legend, each female artisan had her own distinctly identifiable style.

ART & CRAFT

RIGHT: From the 1830s until the early twentieth century, so-called spongeware (in England) and stick spatterware (in America) was a commercial success. Both names indicate how such pieces were decorated: Sponges were cut into various shapes, attached to the ends of sticks, and then dipped into paints and daubed onto the surface of the plates by hand. Here, a Villeroy & Boch plate from the early 1900s.

OPPOSITE: The vividly colored, stylized floral pattern on this circa 1820 Spode plate is reminiscent of sixteenth-century Iznik wares, a type of pottery made in the Ottoman Empire (modern-day Turkey).

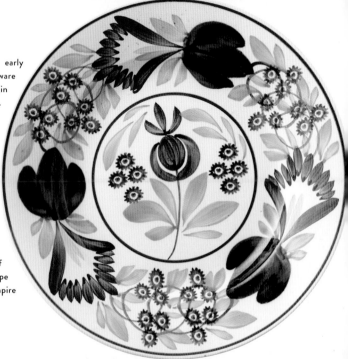

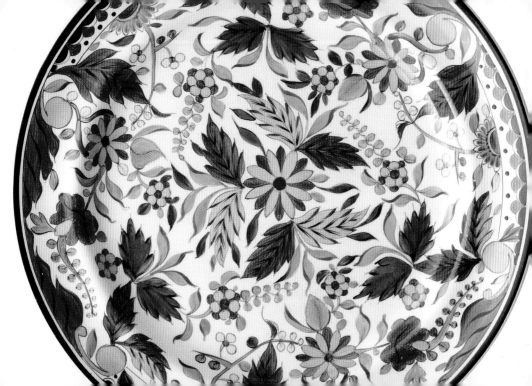

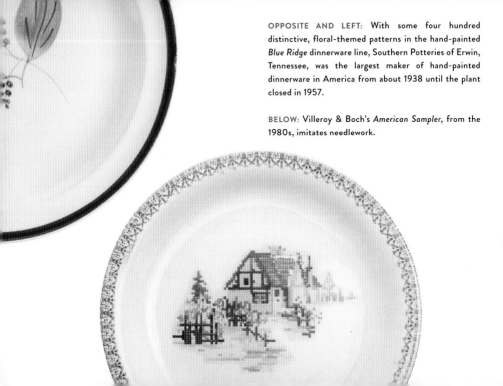

OPPOSITE AND LEFT: With some four hundred distinctive, floral-themed patterns in the hand-painted *Blue Ridge* dinnerware line, Southern Potteries of Erwin, Tennessee, was the largest maker of hand-painted dinnerware in America from about 1938 until the plant closed in 1957.

BELOW: Villeroy & Boch's *American Sampler*, from the 1980s, imitates needlework.

A ROOSTER IN THE KITCHEN

In many cultures a rooster in the kitchen is said to bring good luck to the household, so it's common to find rooster-emblazoned dishes from all time periods.

METLOX POTTERY'S RED ROOSTER (1955–79)

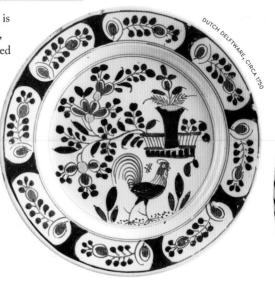

DUTCH DELFTWARE, CIRCA 1750

TRADITIONAL DERUTA PATTERN

METLOX POTTERY'S CALIFORNIA PROVINCIAL (1956–82)

GIEN, FRANCE, 1950s

PAINTING LADIES

The advent of the transfer-printing process in the late 1700s signaled the beginning of the end for hand-painted china. Today, the art of china painting is most often practiced as a passionate hobby.

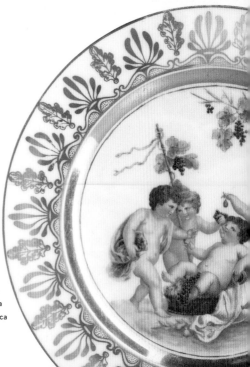

China painting was an acceptable pastime for cultivated young ladies in the nineteenth century. Here, two French porcelain blanks were decorated by the aristocratic Leigh sisters, Julia (putti, RIGHT) and Caroline (shells, OPPOSITE), in England, circa 1820.

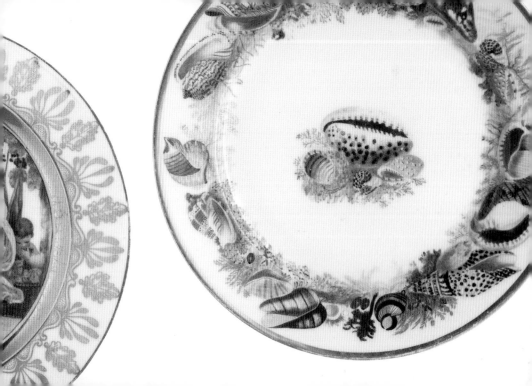

BESPOKE TABLEWARE

If you're in the market for something a little more personal to use on your table, check out the work of these potters. Because they do all the work themselves in small batches, you'll get dishes that truly reflect your style.

For her *Coastal Ceramics*, Alison Evans draws inspiration from the natural forms she spots during walks along the shores and tidal pools of Maine's coast.

Kristen Wicklund's *Little Snackers* were inspired by the need she saw for flat-bottomed, high-sided pieces that make it easy to scoop out snacks like hummus and salsa.

Asya Palatova's porcelain slip glazes are distinctively translucent. She creates her own transfer designs from the vintage printed ephemera that she collects.

RIGHT AND BELOW: Frances Palmer has a devoted following for both her custom-order hand-thrown and glazed pieces (below) as well as her manufactured line of Pearl Ware (right), produced in collaboration with Niagara Ceramics in Buffalo, New York.

OPPOSITE: Potters have been making salt-glazed stoneware in rural North Carolina for centuries. Jugtown Pottery was founded in 1917 to keep the tradition alive.

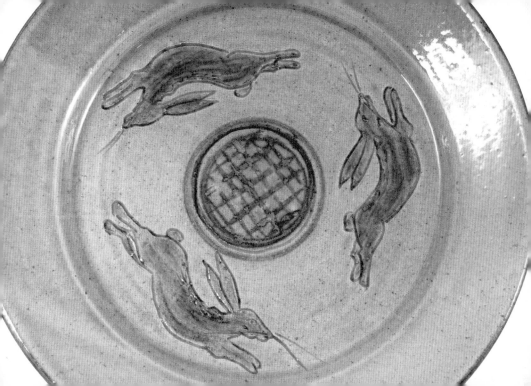

The groovy patterns and distinctive colors of Jill Rosenwald's ceramic pieces have proven so popular that she has recently been commissioned to design bedding, rugs, and furniture.

That trademarked little black squiggle on every piece of pottery made by McCartys, which is based in Merigold, Mississippi, represents the Mississippi River—the source of the clay they use.

RIGHT: Michele Michael impresses cloth into the soft porcelain clay to create the linen texture of her Elephant Ceramics collections. The resulting surfaces and shapes are always one of a kind

OPPOSITE: Miranda Thomas carves designs into a layer of slip that coats the hand-thrown stoneware body.

RIGHT AND BELOW: Potter Pat Girard treats the plate surfaces like a canvas to create designs that are abstract yet grounded in traditional methods and techniques.

OPPOSITE: For her "Fern Plates," Ellen Grenadier impresses fronds into the wet clay before staining the pieces with a copper-tinted glaze.

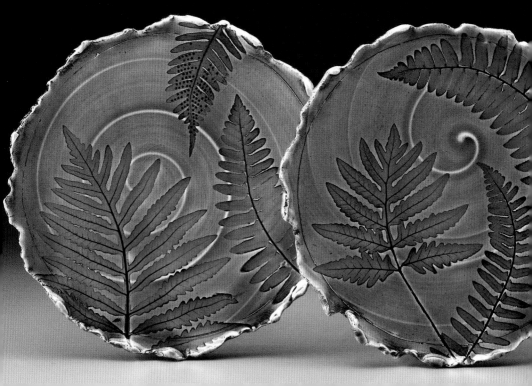

Terrafirma Ceramics, founded by Ellen Evans in 1978, is known for its textural patterns. For *Braid*, porcelain slip is brushed on through a textile used as a stencil.

No two pieces created by Eve Behar are ever exactly alike. She draws inspiration from mid-twentieth-century ceramics.

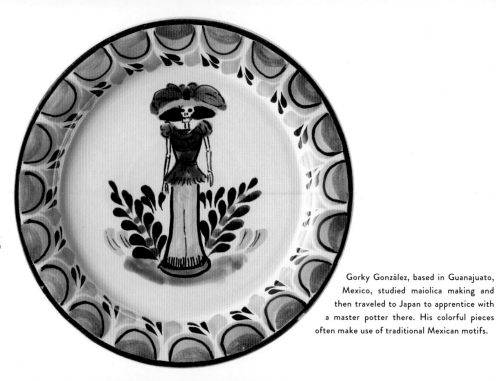

Gorky González, based in Guanajuato, Mexico, studied maiolica making and then traveled to Japan to apprentice with a master potter there. His colorful pieces often make use of traditional Mexican motifs.

Old Rose is the most popular pattern from Ireland's Nicholas Mosse Pottery.

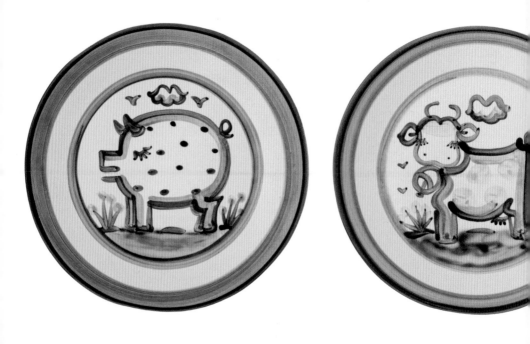

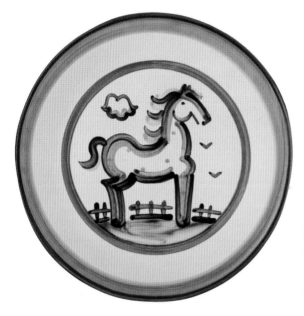

Mary Alice Hadley started designing ceramics in the 1930s and set up a pottery in 1944. The Hadley Pottery in Louisville, Kentucky, still makes her patterns by hand. Here, pig, cow, and horse plates from the *Country* line.

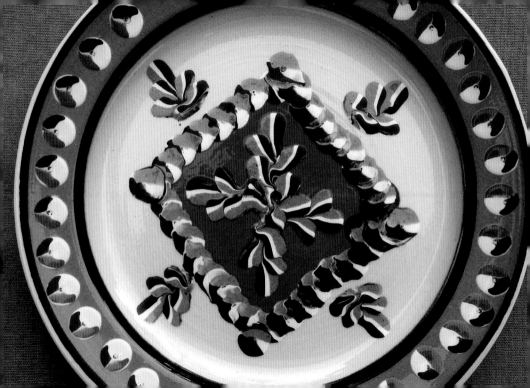

OPPOSITE: Don Carpentier utilizes techniques and molds from the late eighteenth and early nineteenth centuries to create his vivid reproductions. That bold red is the natural color of an iron-rich clay that he gathers from a streambed in Albany County, New York.

RIGHT: Lenore Lampi's decorative birch plate mimics the texture as well as the look of real tree bark.

Lisa Neimeth presses found and vintage objects—old Cracker Jack charms, bisque figurines, twigs, string, rocks, machine parts—and traces the shapes into clay. She then dries, sands, and glazes the pieces up to three times to achieve her distinctively muted matte finishes.

ARTISTIC VISIONS

Sure, plates have a quotidian—even humble—purpose. But that hasn't stopped some of the world's most famous artists and architects from having a go at designing them.

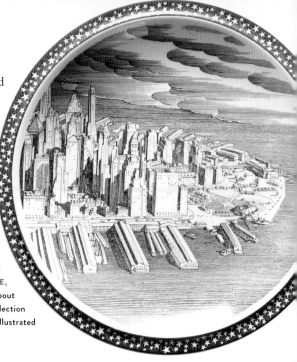

Rockwell Kent's *Our America* featured thirty views of American landscapes (RIGHT, a dramatic aerial view of Manhattan), while *Salamina* (OPPOSITE, LEFT) was adapted from the artist's 1935 book about Greenland. OPPOSITE RIGHT, a plate from a collection based on a best-selling edition of *Moby-Dick* Kent illustrated in 1930.

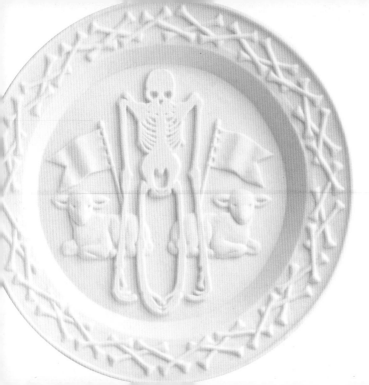

LEFT: Unglazed "biscuit" porcelain has a chalky white texture. Dutch artists Job Smeets and Nynke Tynagel, aka Studio Job, introduced their high-relief Biscuit collection in 2006. Here, *Coded Message*.

OPPOSITE: *Set of Four Plates*, a pattern from 2007 on Limoges porcelain, decorated with sketches by French artist-designer Pierre Charpin.

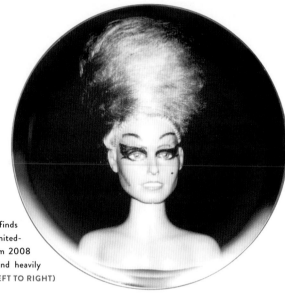

Filmmaker John Waters's love of kitsch finds its perfect expression in *The Girls*, a limited-edition set of three porcelain plates from 2008 adorned with photos of his bewigged and heavily made-up mannequin housemates (FROM LEFT TO RIGHT) Kathy, Tina, and Kim.

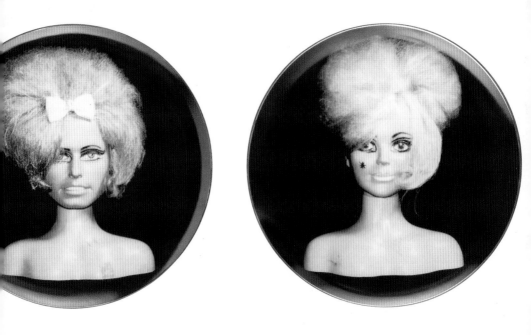

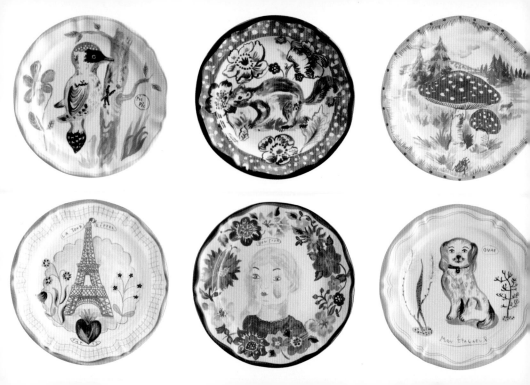

Cheerful and nostalgic, childlike and folksy, the designs of French artist Nathalie Lété adorn a set of dishes introduced at Anthropologie in 2007. OPPOSITE, clockwise from above left: "Woodpecker," "Ecureuil," "Champignons," "Dog," "Petite Fille," and "Eiffel Tower." RIGHT: "Octopus."

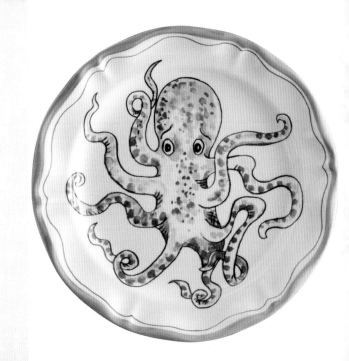

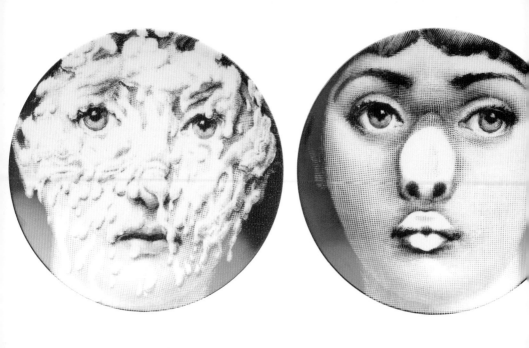

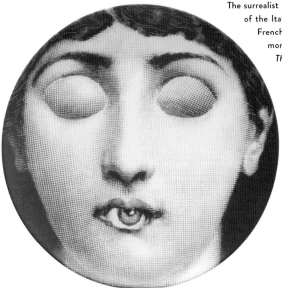

The surrealist Piero Fornasetti was so captivated by an illustration of the Italian soprano Lina Cavalieri in a nineteenth-century French fashion magazine that he was inspired to generate more than five hundred images based on it. The resulting *Themes & Variations* series lives on in some 350 plates. Here, FROM LEFT TO RIGHT: No. 142, "Cake on Face," No. 254, "Pressed Against Glass," and No. 17, "Eye in Mouth."

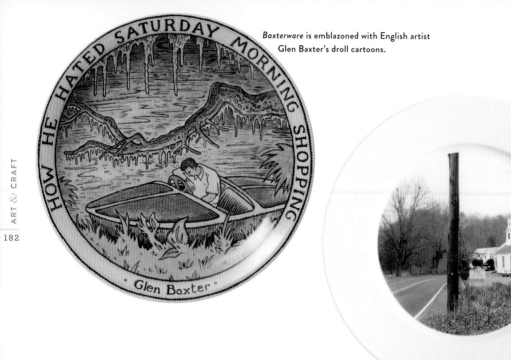

HOW HE HATED SATURDAY MORNING SHOPPING

· Glen Baxter ·

Baxterware is emblazoned with English artist
Glen Baxter's droll cartoons.

The traditional gold rim on Anton Ginzburg's *Plate with Expanding Rim* (circa 2004) expands to coat the back with 22K luxury.

For his *Upstate Collection* of five plates (2002), Constantin Boym came up with an ironic take on souvenir plates, printing each plate with a digital photo of unknown, nondescript regions in upstate New York.

OPPOSITE: Pop artist Roy Lichtenstein designed this groovy screen-printed, primary-colored paper plate for the short-lived shop On First in New York City. It closed before these plates made it onto the shelves, and the cellophane-wrapped packages sat in storage for years before finding their way to the art market. Today they are highly prized—there's even one in the collection of London's Tate Modern.

RIGHT: Famous for designing his life to perfection, impressionist painter Claude Monet designed not one but two porcelain services for his house at Giverny, both of which can be bought today (see the other pattern on page 444).

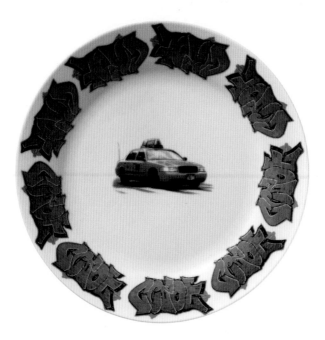

LEFT: Nicholas Lovegrove and Demian Repucci's 2007 *New York Delft* dinner plate with a taxicab and graffiti is a contemporary riff on traditional blue and white.

OPPOSITE: Frank Lloyd Wright designed this pattern, circa 1916, for the cabaret of the Imperial Hotel in Tokyo; it is still manufactured by Noritake.

The Hair Disguiser Dish (2003) by Ana Mir embodies a diner's worse nightmare by embedding a human hair in the glaze

OPPOSITE: James Victore's *Dirty Dishes* collection (2009) started out as plates stolen from restaurants and scribbled with sketches and messages in black Magic Marker.

LEFT: Ceramic artist Molly Hatch decorates the surfaces of her pieces with patterns and motifs taken from seventeenth- and eighteenth-century Chinese export porcelain. To emphasize their painterly qualities, she often makes porcelain frames to hang them on the wall.

OPPOSITE: Cindy Sherman's *Madame de Pompadour (née Poisson)* dinner set (1990) bears photographs of the artist dressed as Louis XV's famous mistress on French porcelain enameled with the typically eighteenth-century colors of yellow, rose, apple green, and royal blue.

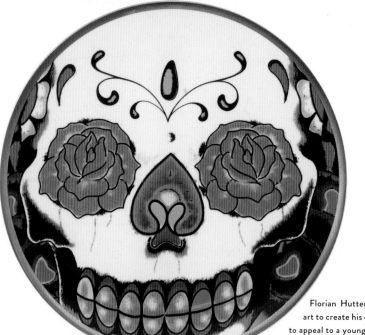

Florian Hutter took inspiration from tattoo art to create his edgy *Inkhead* (2009), designed to appeal to a younger generation.

Starting in 2008, Ink Dish, a new company out of San Diego, California, enlisted world-famous tattoo artist Paul Timman to create several patterns, including *Irezumi*, inspired by traditional Japanese tattooing techniques.

SPODE

After an apprenticeship with the master Staffordshire potter Thomas Whieldon (see examples of Whieldon's tortoiseshell ware on page 84), Josiah Spode opened his own factory in Stoke-on-Trent in 1770. Here, he and his son refined the process for transfer-printing engraved designs onto ceramics and perfected the recipe for fine bone china, ensuring that the family's name would grace some of the finest tableware ever produced.

The company remained a family business until the Spode heirs, following Josiah III's sudden death in 1829, sold their shares to William Taylor Copeland and Thomas Garrett in 1833. Though the company officially became known as Copeland and Garrett, pieces from this 133-year period are often referred to as Copeland Spode and were marked with both names owing to Spode's continued prestige. The business was sold again in 1966, and in honor of the company's two-hundredth anniversary in 1970, the new owners rechristened themselves Spode Ltd. A few years later they merged with Royal Worcester, but in 2009, on the verge of bankruptcy, Royal Worcester Spode was acquired by Portmeirion (makers of the famous *Botanic Garden* line; see page 207). Today, the factory produces just four iconic Spode patterns, including *Blue Italian* (see page 68) and the iconic *Christmas Tree* (see page 387), but the Spode name lives on and continues to signify quality craftsmanship.

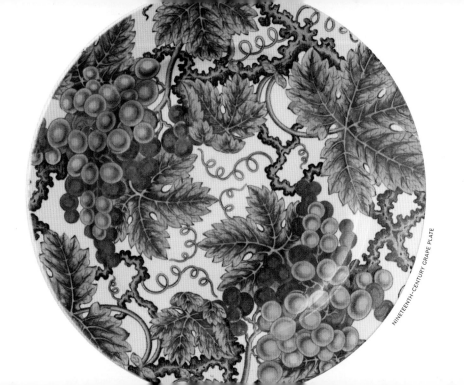

NINETEENTH-CENTURY GRAPE PLATE

FLORA & FAUNA

JUST AS THE POTTER CREATES beautiful porcelain out of mud, so the chef transforms difficult and at times unappetizing raw ingredients into delicious, mouthwatering works of art. Such transformations have often been represented in the decor of dining rooms: carved wood panels and still-life paintings featuring the fruits of the harvest as well as dead game were common in dining rooms well into the nineteenth century. So it should come as little surprise that representations of flora and fauna are some of the most common decorations on plates.

Flowers have been a favorite motif on all kinds of ceramics for centuries. Just a few years after the formula for hard-paste porcelain was discovered in 1709 at Meissen in Germany, the factory's artistic director came up with a floral design, inspired by the familiar wares of the Far East, that was copied all across Europe. For centuries flowers carried symbolic weight in poetry and art, but by the eighteenth century the emblematic meaning associated with flowers from the Middle Ages to the Renaissance had started to give way to a genuine interest in and appreciation of flowers in their own right.

Of course, nature is the realm of the scientist as well as the artist. During the eighteenth

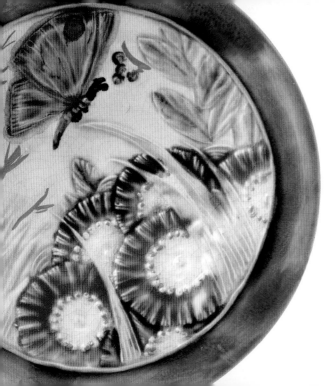

ABOVE: With its emblem composed of delicate flowers, *Floral Armorial*, manufactured by Spode for Tiffany & Co. in the early 1960s, is a pretty little twist on aristocratic china.

LEFT: In the late 1800s French art potters in Limoges created Barbotine ware, casting slip into three-dimensional naturalistic forms, as seen on this plate, circa 1900.

century, there was a move toward ever more realistic and accurate depictions of nature, as exemplified by the work of the Swedish botanist Linnaeus, whose close observation of plants led him to devise the modern system of taxonomy, and of the naturalist John James Audubon, whose *Birds of America* depicted more than seven hundred North American species that he had closely observed in his fieldwork. China painters took inspiration from the detailed artworks that accompanied this scientific revolution and brought a new spirit of realism to their work. Botanical illustrations became very popular for dessert sets, with the Latin name of the depicted plant often indicated on the backs of the plates. By acquiring dishes decorated in this way, people aligned themselves with the new scientific attitudes and showed off their pleasure in the cultivated delights of the garden. (The iconic

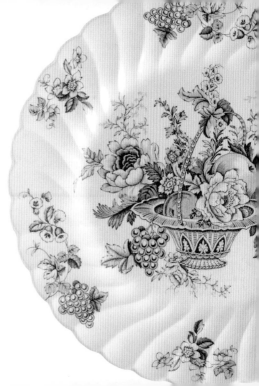

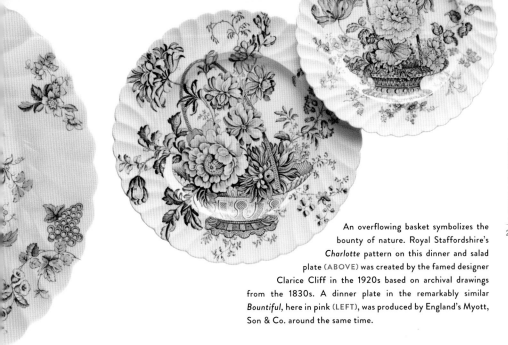

An overflowing basket symbolizes the bounty of nature. Royal Staffordshire's *Charlotte* pattern on this dinner and salad plate (ABOVE) was created by the famed designer Clarice Cliff in the 1920s based on archival drawings from the 1830s. A dinner plate in the remarkably similar *Bountiful*, here in pink (LEFT), was produced by England's Myott, Son & Co. around the same time.

Flora Danica pattern, shown on page 70, was a product of this scientific spirit.)

In addition to flowers and vegetables, birds, fish, and hunting were also popular motifs on dishes. In fact, fish plates are quite common finds because good form once required a unique, separate set of dishes for the fish course of any formal banquet.

We may no longer spend all our daylight hours hunting, gathering, and farming like our ancient forebears, but we may still grow weary at the mere thought of running into the supermarket after a long day at the office. Humans have long entertained fantasies of nature yielding up her fruits without our having to make any effort. So, it makes a kind of poetic sense for all this natural bounty to be one of the most enduring decorative motifs for dishes.

RED WING'S CAPISTRANO, 1953

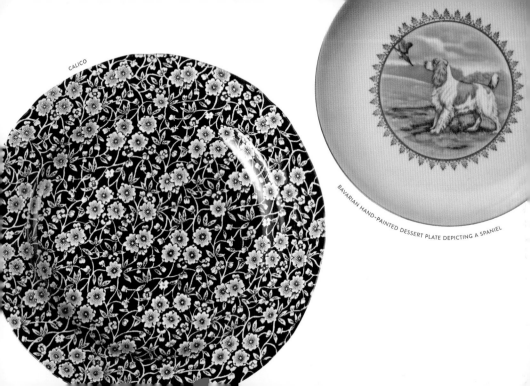

CALICO

BAVARIAN HAND-PAINTED DESSERT PLATE DEPICTING A SPANIEL

FLOWER POWER

Turn your table into a lush, colorful garden.

RIGHT: Hand-painted "Lavender Leav'd Hermannia" (or *Hermannia lavendulifolia*) on a circa 1800 plate by Davenport, an English manufacturer active from 1794 to 1887.

OPPOSITE: An overgrown, allover floral pattern on an unmarked English plate.

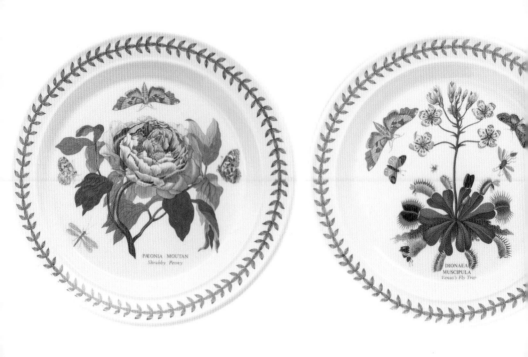

PÆONIA MOUTAN
Shrubby Peony

DIONAEA
MUSCIPULA
Venus's Fly Trap

Founded in 1960, England's Portmeirion Potteries launched its first *Botanic Garden* pieces in 1972 after founder Susan Williams-Ellis bought Thomas Green's 1817 book *The Universal Herbal* and decided to apply the illustrations to tableware. The line adds new patterns every year. FROM LEFT TO RIGHT: "Shrubby Peony," "Venus Fly Trap," and "Blue Passion Flower."

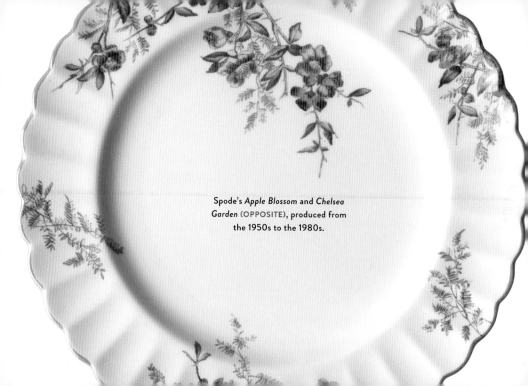

Spode's *Apple Blossom* and *Chelsea Garden* (OPPOSITE), produced from the 1950s to the 1980s.

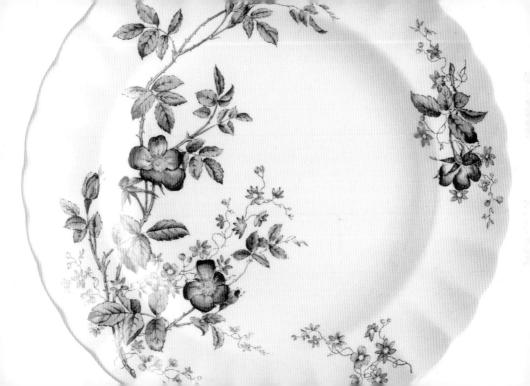

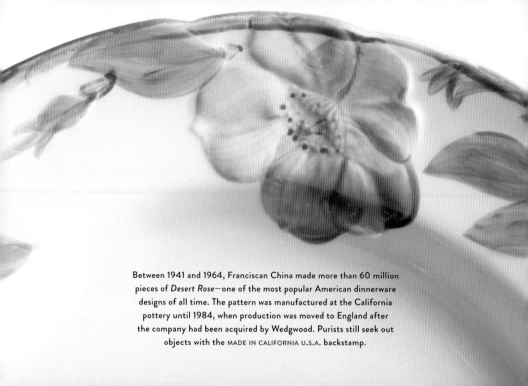

Between 1941 and 1964, Franciscan China made more than 60 million pieces of *Desert Rose*—one of the most popular American dinnerware designs of all time. The pattern was manufactured at the California pottery until 1984, when production was moved to England after the company had been acquired by Wedgwood. Purists still seek out objects with the MADE IN CALIFORNIA U.S.A. backstamp.

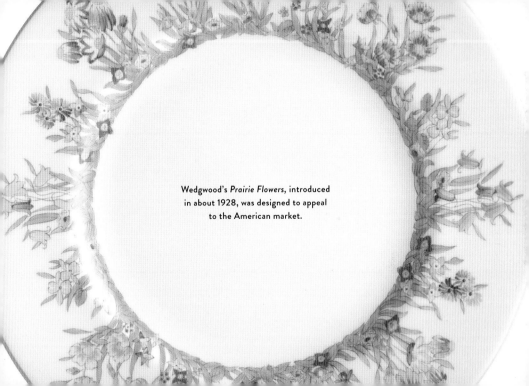

Wedgwood's *Prairie Flowers*, introduced in about 1928, was designed to appeal to the American market.

RIGHT: Hall China's decal-decorated *Crocus*, 1930s.

BELOW: Hand-painted dessert plate with shaped rim, roses, and forget-me-nots, made in Austria for export to the United States, 1920s.

OPPOSITE: Chelsea-Derby dessert plate, circa 1775, with distinctive green-hued decoration.

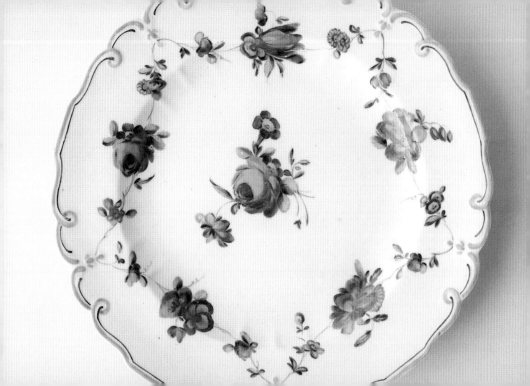

Universal Potteries' *Ballerina* shape with Thistle decal decoration, 1950s.

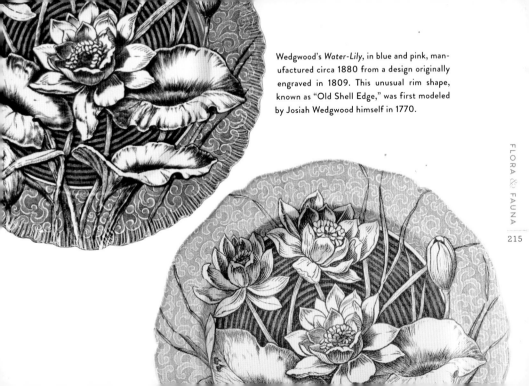

Wedgwood's *Water-Lily*, in blue and pink, manufactured circa 1880 from a design originally engraved in 1809. This unusual rim shape, known as "Old Shell Edge," was first modeled by Josiah Wedgwood himself in 1770.

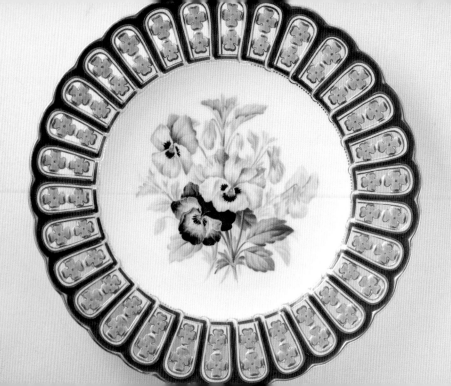

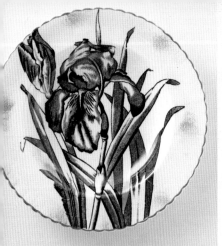

OPPOSITE: Minton dessert plate with hand-painted pansies and the factory's distinctive pierced-rim design, circa 1880.

LEFT: This dramatic iris plate of about 1870 was made by the Trenton Potteries Co., a consortium of five manufacturers in that city.

BELOW: *Wild Poppy*, launched in 1972 by California's Metlox Pottery.

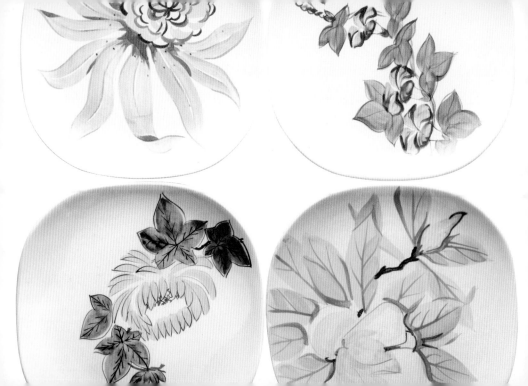

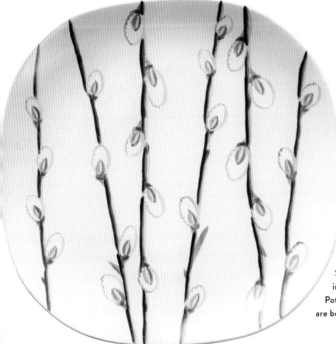

Starting in 1941, and manufactured into the late 1950s, Red Wing Pottery's hand-painted floral designs are both modern and folksy.

CHINTZES

With their intense coloring and densely packed flowers, chintz dinnerware evokes the English countryside in all its lush summer glory.

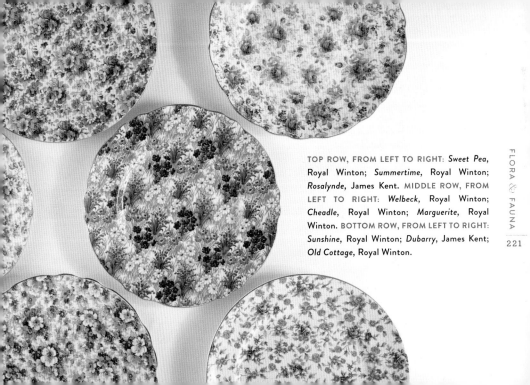

TOP ROW, FROM LEFT TO RIGHT: *Sweet Pea*, Royal Winton; *Summertime*, Royal Winton; *Rosalynde*, James Kent. MIDDLE ROW, FROM LEFT TO RIGHT: *Welbeck*, Royal Winton; *Cheadle*, Royal Winton; *Marguerite*, Royal Winton. BOTTOM ROW, FROM LEFT TO RIGHT: *Sunshine*, Royal Winton; *Dubarry*, James Kent; *Old Cottage*, Royal Winton.

The lush chintz patterns from the preceding pages are so dense and colorful, they deserve a close-up. All of these patterns originally date from the late 1920s into the 1930s. In 1997, noting their popularity among collectors, Royal Winton began remaking some classic patterns, including *Old Cottage*, *Summertime*, and *Welbeck*. FROM LEFT TO RIGHT: *Sweet Pea*, *Marguerite*, *Old Cottage*, and *Sunshine*, all by Royal Winton.

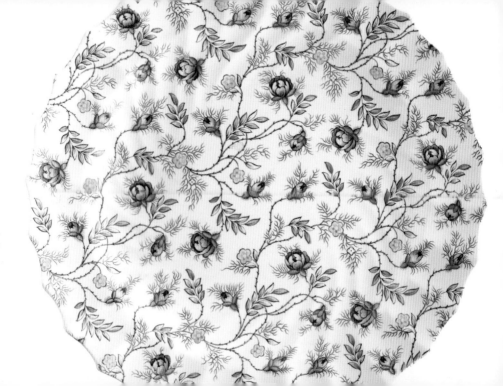

OPPOSITE: Spode manufactured its
Rosebud Chintz from 1954 to 1971.

RIGHT: *Calico* was named for and inspired by
a kind of cheap printed cotton that caught on in
the eighteenth century. English manufacturers soon
were copying the fashionable patterns on domestically
made textiles and, eventually, ceramics.

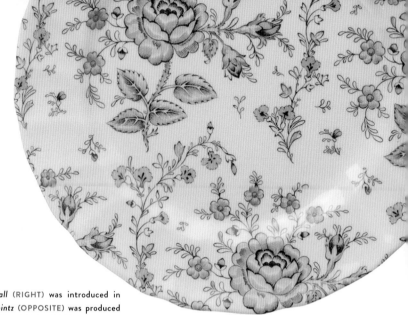

Minton's *Haddon Hall* (RIGHT) was introduced in 1948, while *Rose Chintz* (OPPOSITE) was produced by Johnson Brothers from 1923 to 2003.

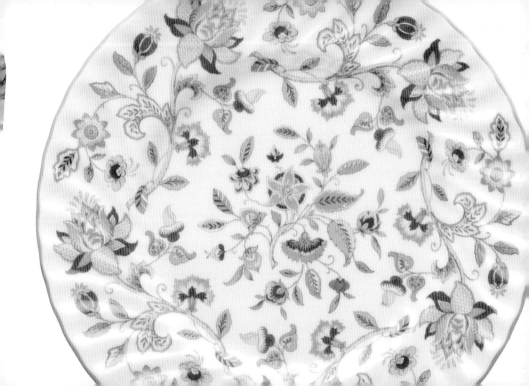

INTO THE WOODS

Leaves, twigs, and even bark have inspired some of the most beautiful dinnerware designs.

A collection of molded nineteenth-century dessert plates, including some in majolica, a term coined by England's Minton Ceramic Factory in 1851 to denote pieces inspired by Renaissance Italian maiolica wares. TOP ROW, FROM LEFT TO RIGHT: Brown and green majolica plate, Wedgwood sunflower plate in white, green pearlware leaf plate, blue pearlware leaf plate. BOTTOM ROW, FROM LEFT TO RIGHT: Grass-green-edged plate, majolica compote, green pearlware leaf plate, brown and green majolica plate, Wedgwood sunflower plate with allover green glaze.

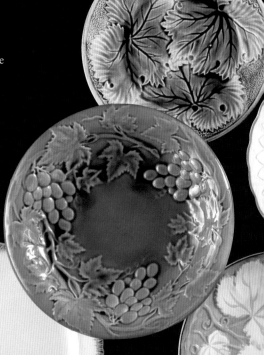

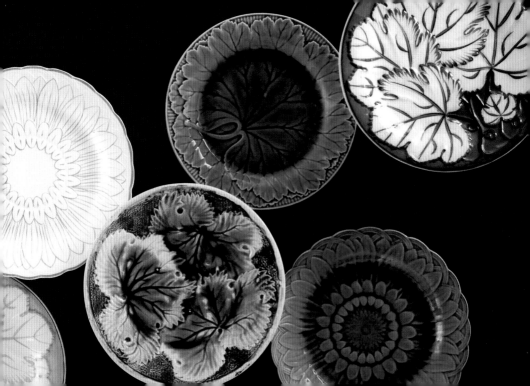

RIGHT: *Woodgrain* dinner plate by the contemporary French ceramic manufacturer Jean-Baptiste Astier de Villatte.

BELOW: According to legend, Napoleon Bonaparte himself dined from Wedgwood's *Napoleon Ivy*, designed in 1815, during his exile on the island of St. Helena (1815–21).

OPPOSITE: From the 1950s to the 1970s, the bold, bright print designs of Vera Neumann, often big pop-arty takes on motifs from nature, appeared on place mats, dish towels, tablecloths, and ceramic pieces. Here, *The Birches*, produced for just a few years in the 1970s.

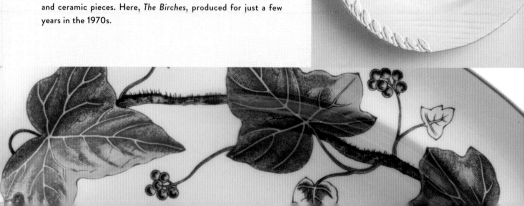

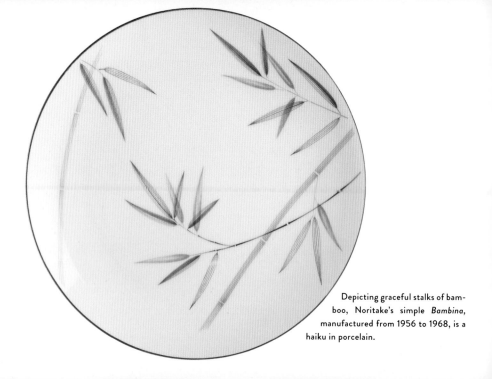

Depicting graceful stalks of bamboo, Noritake's simple *Bambina*, manufactured from 1956 to 1968, is a haiku in porcelain.

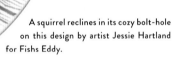

A squirrel reclines in its cozy bolt-hole
on this design by artist Jessie Hartland
for Fishs Eddy.

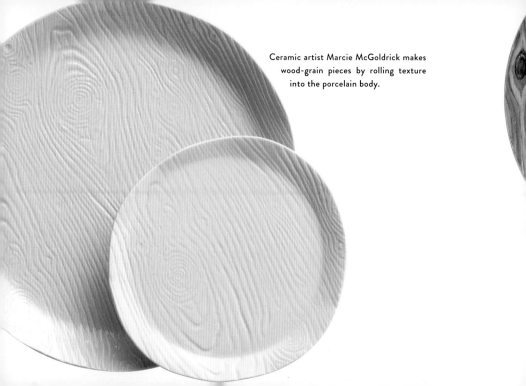

Ceramic artist Marcie McGoldrick makes wood-grain pieces by rolling texture into the porcelain body.

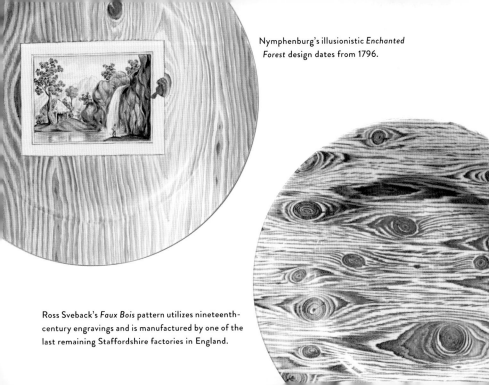

Nymphenburg's illusionistic *Enchanted Forest* design dates from 1796.

Ross Sveback's *Faux Bois* pattern utilizes nineteenth-century engravings and is manufactured by one of the last remaining Staffordshire factories in England.

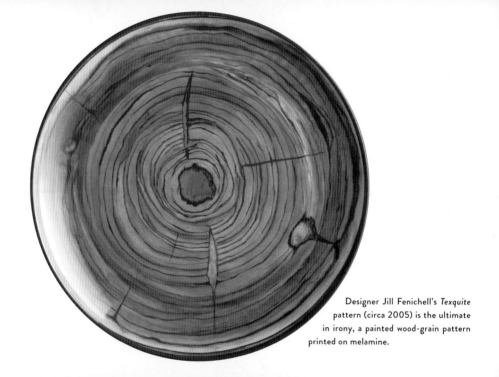

Designer Jill Fenichell's *Texquite*
pattern (circa 2005) is the ultimate
in irony, a painted wood-grain pattern
printed on melamine.

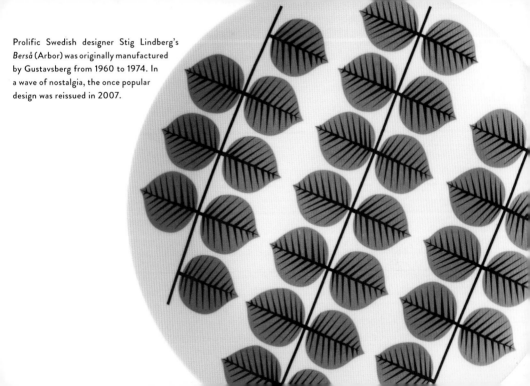

Prolific Swedish designer Stig Lindberg's *Berså* (Arbor) was originally manufactured by Gustavsberg from 1960 to 1974. In a wave of nostalgia, the once popular design was reissued in 2007.

NATURE'S BOUNTY

Dishes that evoke Mother Nature's
fecundity and generosity are always
appropriate on a well-laid table in a
well-appointed dining room.

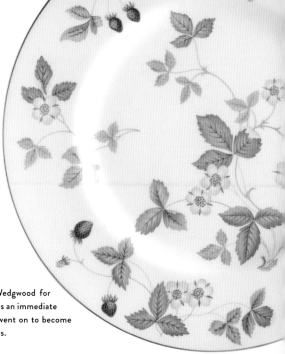

Wild Strawberry was manufactured by Wedgwood for
Tiffany & Co. starting in 1965. The line was an immediate
sellout upon its arrival in New York and went on to become
one of the company's best-selling patterns.

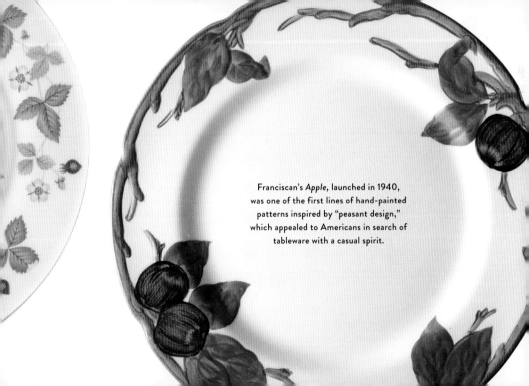

Franciscan's *Apple*, launched in 1940, was one of the first lines of hand-painted patterns inspired by "peasant design," which appealed to Americans in search of tableware with a casual spirit.

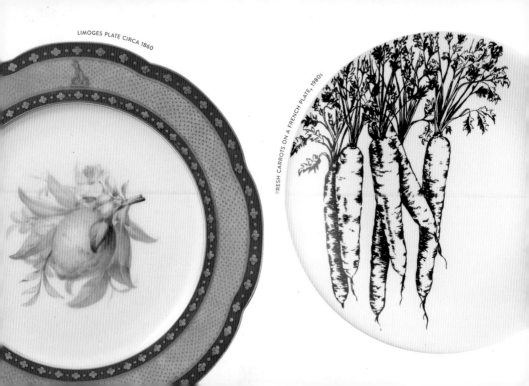

LIMOGES PLATE CIRCA 1860

FRESH CARROTS ON A FRENCH PLATE, 1980s

JOHNSON BROTHERS' GOLDEN APPLES, 1950s

MELON PLATE, UNMARKED, 1970s

ONION-SHAPED PLATE, 1920s, FROM CARLSBAD CHINA COMPANY

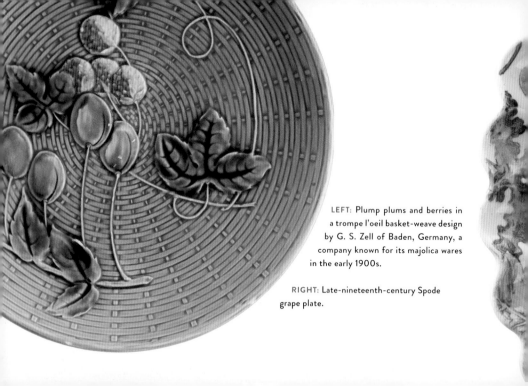

LEFT: Plump plums and berries in a trompe l'oeil basket-weave design by G. S. Zell of Baden, Germany, a company known for its majolica wares in the early 1900s.

RIGHT: Late-nineteenth-century Spode grape plate.

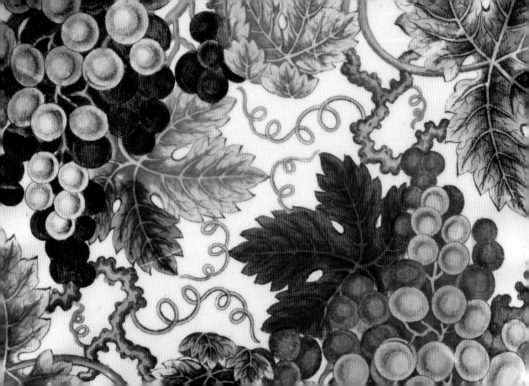

RIGHT AND BELOW: Lest we forget where food comes from, these two plates serve as a reminder. The bottom plate, by the Sterling China Co. of Wellsville, Ohio, is perfect for a steakhouse or a backyard barbecue; *Homefarm*, a charming transfer-printed barnyard scene, was made by the Burleigh factory, Stoke-on-Trent, Staffordshire, England, in the early 2000s.

OPPOSITE, ABOVE: Leafy green majolica dessert plate, English, circa 1860.

OPPOSITE, BELOW: A variation on the leaf motif, sometimes also called "dill" plates, unmarked English, 1820s.

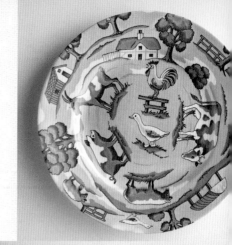

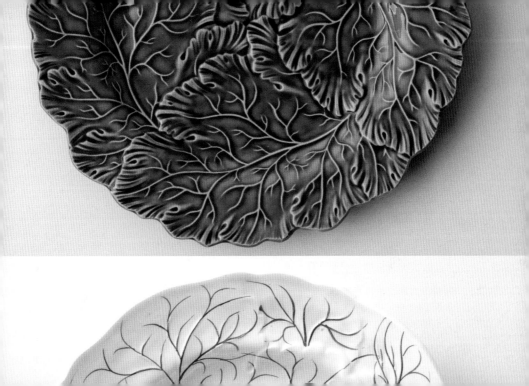

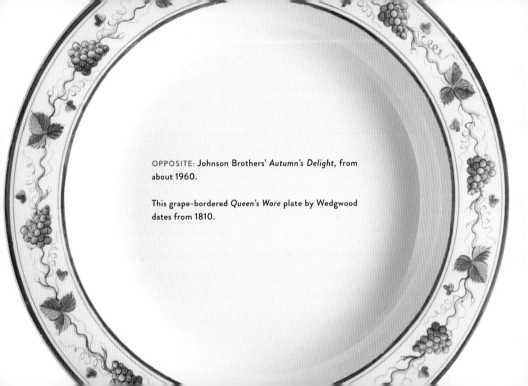

OPPOSITE: Johnson Brothers' *Autumn's Delight*, from about 1960.

This grape-bordered *Queen's Ware* plate by Wedgwood dates from 1810.

UP IN THE AIR

A virtual aviary of bird-decorated plates
ranging from hand-painted to transfer-printed.

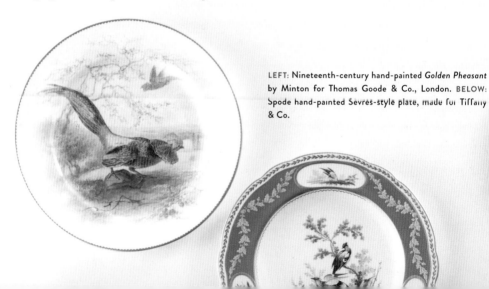

LEFT: Nineteenth-century hand-painted *Golden Pheasant* by Minton for Thomas Goode & Co., London. BELOW: Spode hand-painted Sèvres-style plate, made for Tiffany & Co.

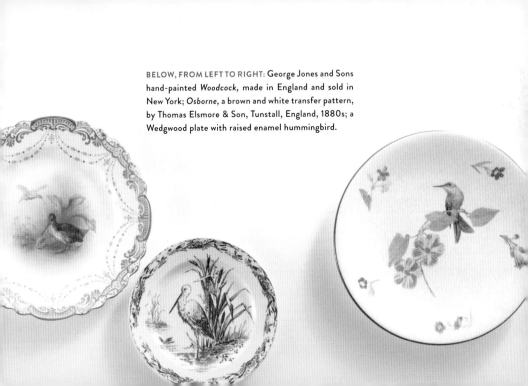

BELOW, FROM LEFT TO RIGHT: George Jones and Sons hand-painted *Woodcock*, made in England and sold in New York; *Osborne*, a brown and white transfer pattern, by Thomas Elsmore & Son, Tunstall, England, 1880s; a Wedgwood plate with raised enamel hummingbird.

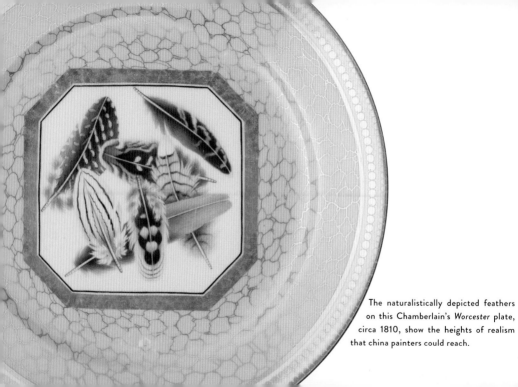

The naturalistically depicted feathers on this Chamberlain's *Worcester* plate, circa 1810, show the heights of realism that china painters could reach.

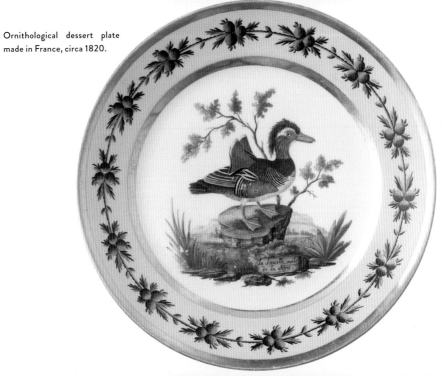

Ornithological dessert plate
made in France, circa 1820.

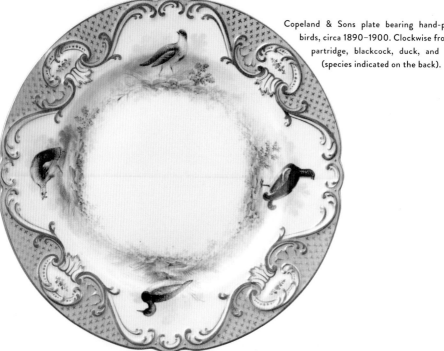

Copeland & Sons plate bearing hand-painted birds, circa 1890–1900. Clockwise from top: partridge, blackcock, duck, and turkey (species indicated on the back).

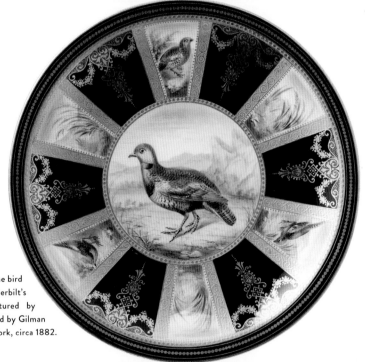

This richly enameled game bird plate is fit for a Vanderbilt's dining room. Manufactured by Crown Derby and retailed by Gilman Collamore & Co., New York, circa 1882.

Dessert plate with hand-colored transfer-printed decoration, Limoges, France, 1950s.

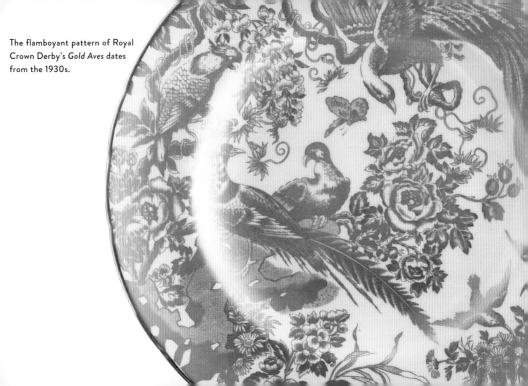

The flamboyant pattern of Royal Crown Derby's *Gold Aves* dates from the 1930s.

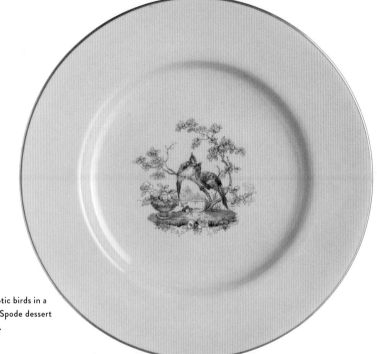

A pair of exotic birds in a
garden on a Spode dessert
plate, 1920s.

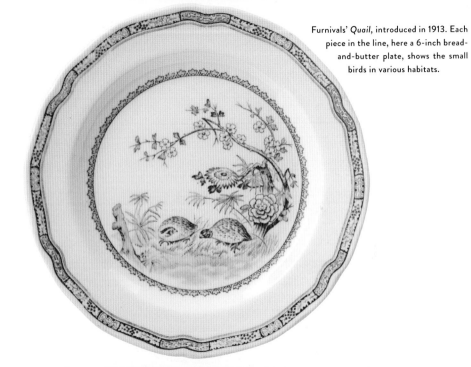

Furnivals' *Quail*, introduced in 1913. Each piece in the line, here a 6-inch bread-and-butter plate, shows the small birds in various habitats.

OPPOSITE: Red Wing Pottery's *Bob White*, introduced in the mid-1950s and produced until 1967, was by far the company's best-selling pattern. Its popularity may have been helped along when the February 1956 *Playboy* centerfold was shown in bed, drinking coffee out of a Bob White cup! RIGHT: With hand-painted flamingos, this plate, made by Harker Pottery of East Liverpool, Ohio, was sold as a souvenir in Florida in the 1950s.

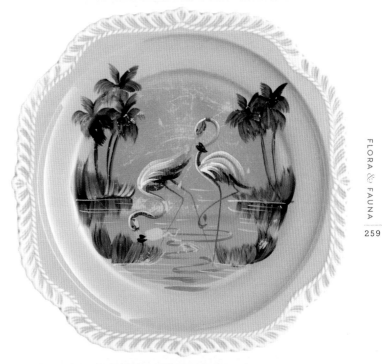

UNDER THE SEA

Gorgeously painted fish plates—for the fish course—were once de rigueur on any grand banquet table.

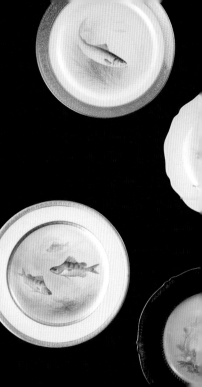

An aquarium full of hand-painted and transfer-decorated fish plates, from about 1890 through the 1920s. TOP ROW, FROM LEFT TO RIGHT: *Salmon*, made by Lenox expressly for Ovington Bros., New York; *Trout*, Royal Doulton; Bodley hand-painted fish plate with raised molded rope border and gold paste decoration; two circa 1890 fish plates by Worcester, one with transfer-printed "netting." BOTTOM ROW, FROM LEFT TO RIGHT: *Perch*, Royal Doulton; an underwater scene painted by B. Albert, made by Theodore Haviland, Limoges, France, for Higgins & Seiter, New York; *Haddock*, Minton, circa 1890; *Short Headed Salmon*, made by Royal Doulton, England, circa 1910.

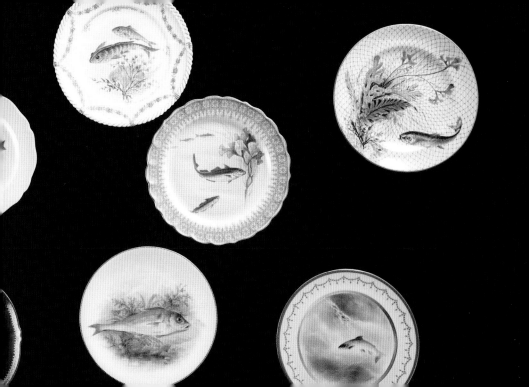

Airbrushed leaping sailfish by
Jackson China of Fall's Creek,
Pennsylvania, 1950s.

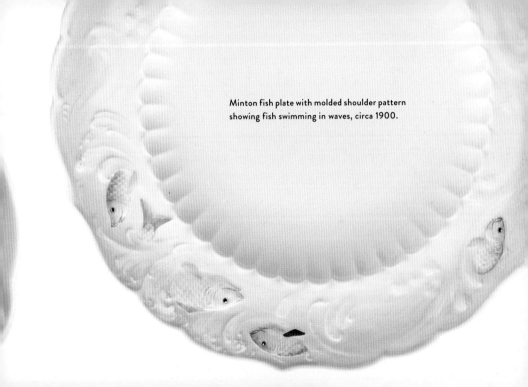

Minton fish plate with molded shoulder pattern showing fish swimming in waves, circa 1900.

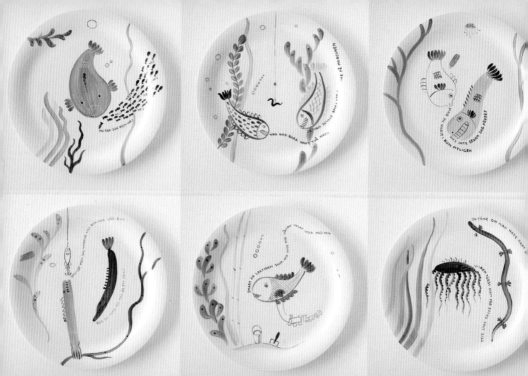

Stig Lindberg's colorful hand-painted Löja line, for Gustavsberg (1948–62), features a school of comically oblivious Swedish fish. Translations of some of the groan-worthy statements include (RIGHT) "Are you coming up with me today?" "No, I'm busy" and (OPPOSITE, BOTTOM RIGHT) "If only I had a glass of water." "How thirsty one gets after salt herring."

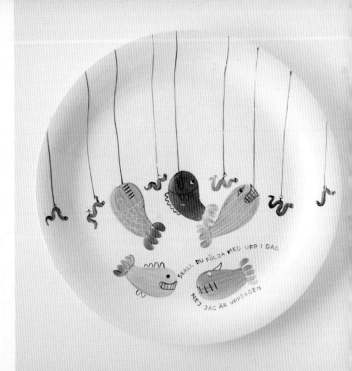

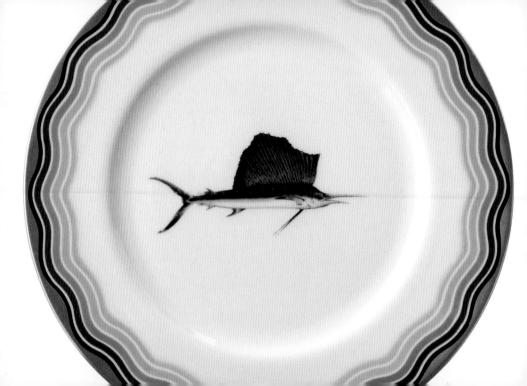

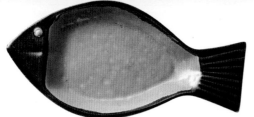

OPPOSITE: Service plate with a sailfish at the center and a border simulating stylized waves, manufactured by Lenox in the 1930s.

ABOVE: This fish-shaped plate, produced from the 1940s through the 1960s, was made by either Zanesville Stoneware or Louisville Pottery—sources just can't agree, but if you love it, does it matter?

RIGHT: Homer Laughlin restaurant ware stenciled lobster platter, 1960s.

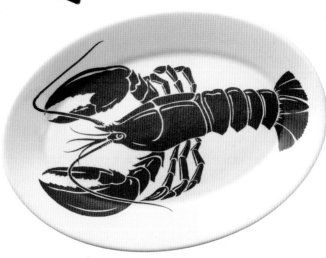

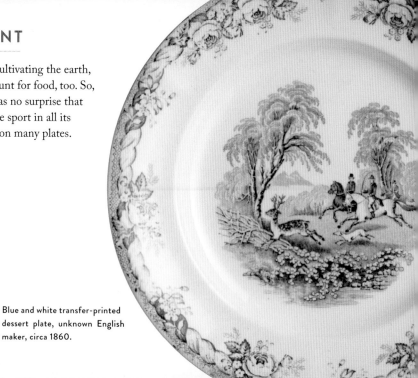

THE HUNT

In addition to cultivating the earth, humans must hunt for food, too. So, it should come as no surprise that depictions of the sport in all its guises show up on many plates.

Blue and white transfer-printed dessert plate, unknown English maker, circa 1860.

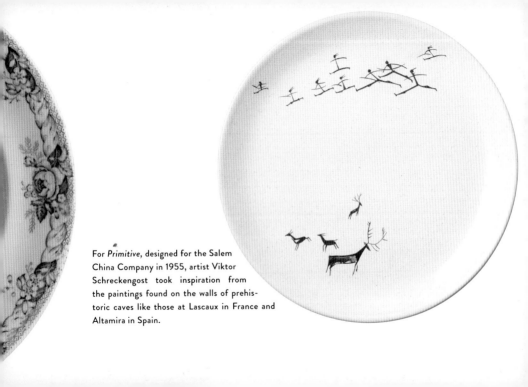

For *Primitive*, designed for the Salem China Company in 1955, artist Viktor Schreckengost took inspiration from the paintings found on the walls of prehistoric caves like those at Lascaux in France and Altamira in Spain.

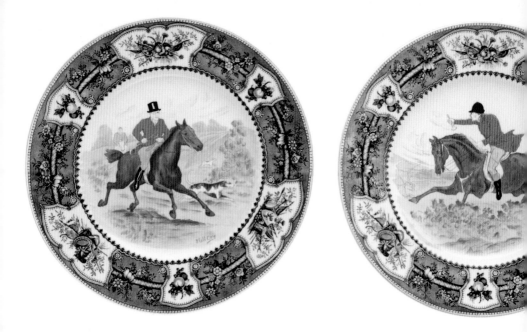

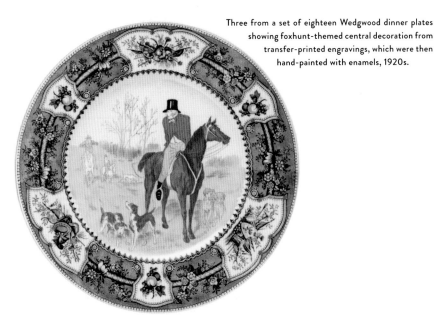

Three from a set of eighteen Wedgwood dinner plates showing foxhunt-themed central decoration from transfer-printed engravings, which were then hand-painted with enamels, 1920s.

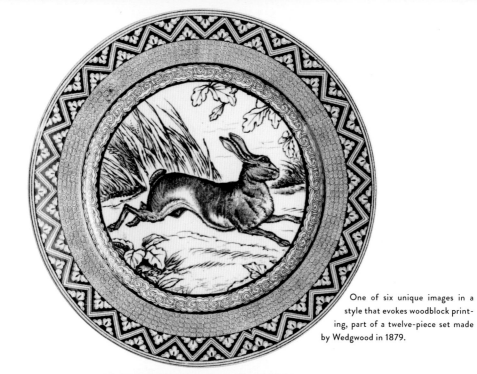

One of six unique images in a style that evokes woodblock printing, part of a twelve-piece set made by Wedgwood in 1879.

One scene ("After a hard day") from a set of ten plates depicting the labors of a pack of hunting beagles, English, early twentieth century.

After a hard day.

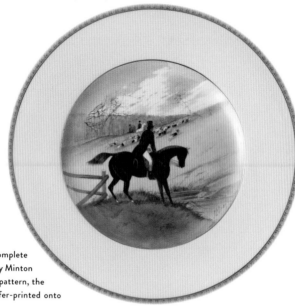

Three examples from a complete
dinner service for twelve by Minton
from the 1920s. For each pattern, the
central scenes were transfer-printed onto
the surface, then painted.

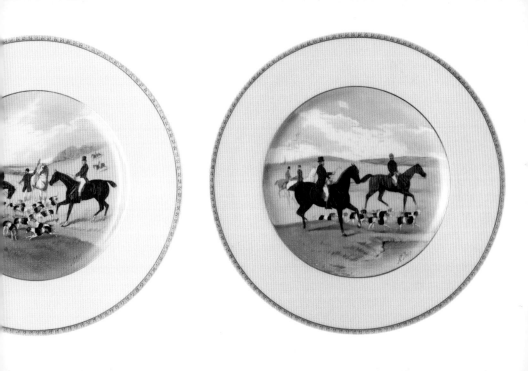

MAN'S BEST FRIEND

Dog lovers, keep a lookout—there's probably a plate commemorating your canine companion.

A beribboned Yorkshire terrier on a plate "made in China" and carried briefly by Urban Outfitters in spring 2010.

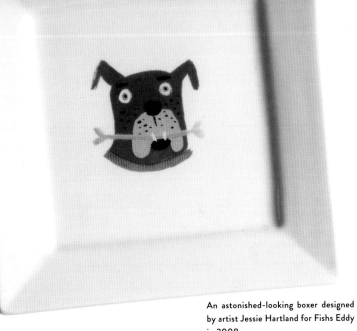

An astonished-looking boxer designed by artist Jessie Hartland for Fishs Eddy in 2008.

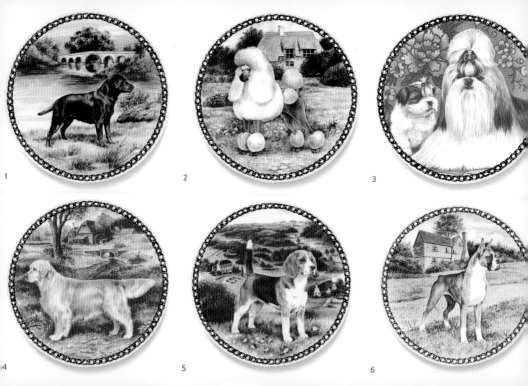

1

2

3

4

5

6

In 1999 Denmark's Lekven Design started offering traditional blue and white porcelain plates depicting more than six hundred dog breeds in pictures created to adhere to international dog-judging standards.

1. Labrador retriever

2. Poodle

3. Shih tzu

4. Golden retriever

5. Beagle

6. Boxer

7. German shepherd

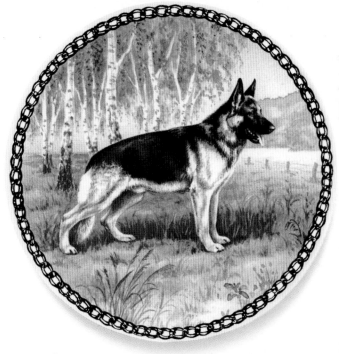

LENOX

In 1889 Walter Scott Lenox and Jonathan Coxon founded the Ceramic Art Company in Trenton, New Jersey (the so-called Staffordshire of America). It was Lenox, who was born in the city and had apprenticed with several firms in the area, who drove the company's artistic vision and eventually assumed full ownership in 1894.

Under Lenox's guidance, the company shifted from making one-of-a-kind art pieces to producing dinnerware using its distinctive ivory-colored bone china body. To reflect the new focus on tableware, the business was renamed Lenox China in 1906. Lenox, who struggled with ill health throughout his life, worked tirelessly to perfect the company's products, with the goal of showing that his American china could compete in strength and beauty with the legendary porcelains of Europe and Asia.

In 1918 Woodrow Wilson commissioned a 1,700-piece state dinner service from the company, the first time American-made china appeared on the White House table. Since then, Lenox has produced five more presidential services: for Franklin D. Roosevelt, Harry S. Truman, Ronald Reagan, Bill Clinton, and George W. Bush. Today the company is still going strong, and its wares can be found in millions of homes around the world.

FLORA & FAUNA

281

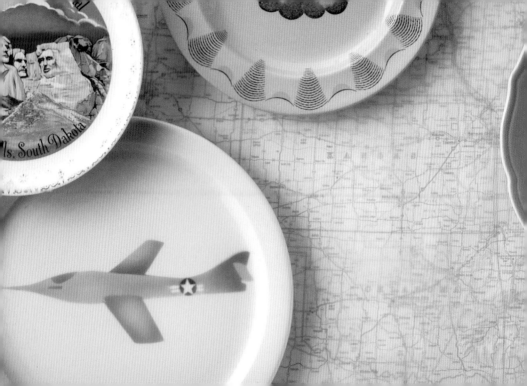

PEOPLE & PLACES

No OBJECT EVOKES DOMESTICITY quite like a dinner plate. And yet this quotidian household object has also been a vehicle by which views of faraway and exotic lands have entered the home. During the first half of the nineteenth century, idealized images of the English countryside, views of India and other distant corners of the British Empire, scenes from literature, copies of famous paintings, depictions of military and naval battles, portraits of historical figures and popular heroes, and exotic animals all began turning up on the dinner table.

The invention of transfer printing in the mid-1700s ushered in this era of cheap and plentiful image-bearing china. In this process, a variant of which is still in use today, ink is transferred from an engraved copperplate to damp tissue paper, which is then applied to a fired ceramic form. The piece is fired again at a low temperature to fix the inked design, then glazed and fired a third time at a higher temperature. Because the resulting design is actually under the glaze, it is more durable than decoration painted on the surface.

After the War of 1812, savvy English manufacturers began producing designs specifically for the American market. These included images of buildings and landmarks (Mount Vernon, Harvard College), landscapes and natural wonders (Niagara Falls, the Hudson River), American cityscapes, marvels of engineering (the Erie Canal, the Baltimore & Ohio Railroad),

LE COUREUR ("THE RUNNER"), MANUFACTURED BY CREIL ET MANTEREAU, CIRCA

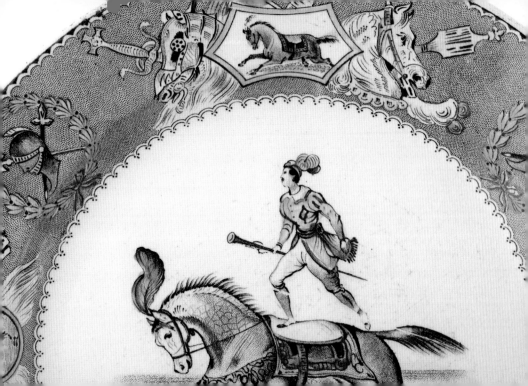

and, of course, the Founding Fathers and other patriotic heroes. These dishes were sold not as souvenirs but rather for everyday use, and it was only in the later nineteenth century, when the plates had been relegated to the attic in favor of more fashionable tableware, that they began to be valued as collectibles, and so migrated to walls and shelves.

In 1899 R. T. Haines Halsey, a New York stockbroker and collector of Americana, published a seminal guide to collecting transferware, as these printed ceramics are known. His *Pictures of Early New York on Dark Blue Staffordshire Pottery, Together with Pictures of Boston and New England, Philadelphia, the South and West* listed a fairly comprehensive 222 such patterns. While later researchers have since identified nearly 700 uniquely American patterns, none has surpassed Halsey's passion for the material and his

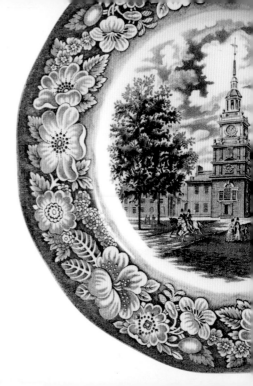

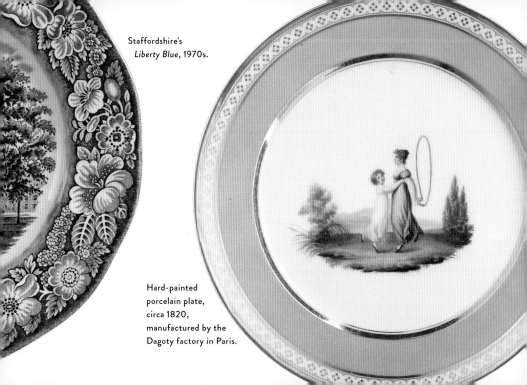

Staffordshire's
Liberty Blue, 1970s.

Hard-painted
porcelain plate,
circa 1820,
manufactured by the
Dagoty factory in Paris.

eye for the telling detail. In fact, his book—only 298 copies of which were printed—is itself now a collector's item. Halsey and his wife carefully photographed the pieces in their own collection, and he had the photogravures printed in a specially formulated ink to more faithfully render the blue coloring of the original objects.

While the golden era of English transferware was the 1800s, these pieces helped create a taste for printed and painted pictures on plates—think souvenirs and restaurant ware—that continues today.

Mason's "Patent Ironstone China" plate in the *Vista* pattern.

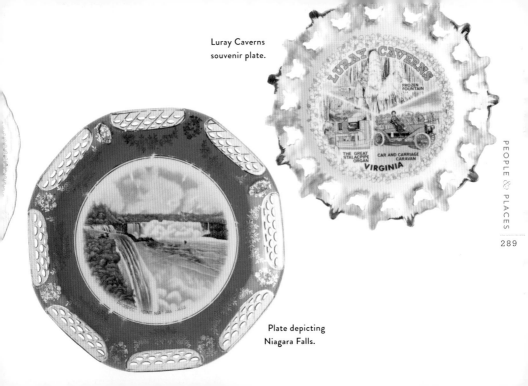

Luray Caverns
souvenir plate.

Plate depicting
Niagara Falls.

TRAVEL AND TRANSPORT

Planes, trains, coaches, and boats . . .
Dream of your next journey without
leaving the dinner table.

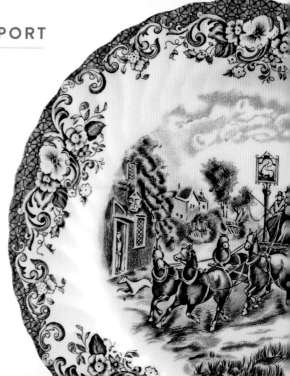

RIGHT: Only the blue version of Johnson Brothers' coaching scenes was shipped to the U.S. market from 1963 to 1991.

OPPOSITE: *The Heritage Hall* pattern by Johnson Brothers was first sold at Sears in the late 1970s.

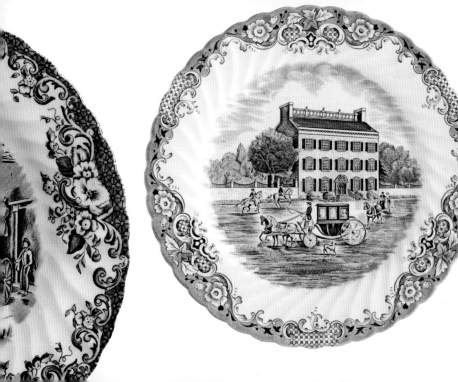

A coaching scene made by Walker China of Bedford, Ohio.

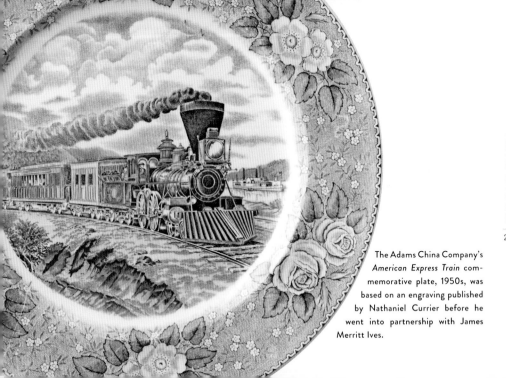

The Adams China Company's *American Express Train* commemorative plate, 1950s, was based on an engraving published by Nathaniel Currier before he went into partnership with James Merritt Ives.

OPPOSITE: Artist Eric Ravilious designed his *Travel* series for Wedgwood in the late 1930s, but, fearing that they were too "modern" for the marketplace, the company didn't issue them until the 1950s.

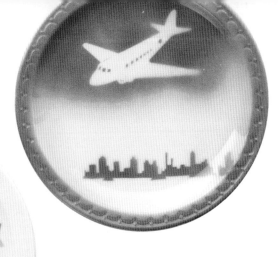

LEFT AND ABOVE: Jet age plates from the 1960s. The airbrushed blue fighter was made by Jackson China of Falls Creek, Pennsylvania, and Syracuse China used its trademarked Shadowtone process to create this pink jumbo jet and skyline.

PRETTY VIEWS

In the last third of the eighteenth century tourism was still rare, but as English traveler-commentators such as William Gilpin encouraged people to look at the country-side with fresh eyes, Staffordshire manufacturers produced hundreds of transferware patterns celebrating the scenery of the world.

RIGHT: Luncheon plate in *Breadalbane*, named for a region of the Scottish Highlands, circa 1890, by Brown-Westhead, Moore & Co. of Cauldon, England. Note the regional references in the tartanlike rim and the garland of thistles bordering the well.

OPPOSITE: Johnson Brothers' *The Old Mill*, produced from 1952 to 1977.

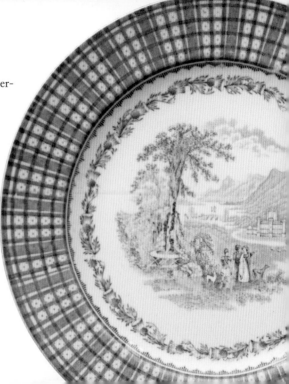

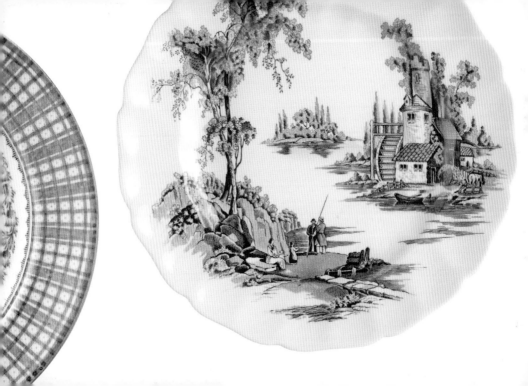

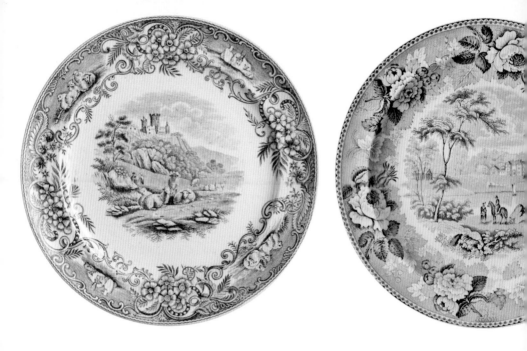

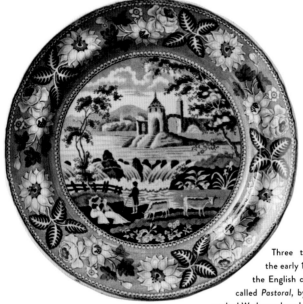

Three transfer-printed plates from the early 1800s showing idyllic views of the English countryside in pink, a pattern called *Pastoral*, by an unknown maker; brown, marked Wedgwood; and blue, unmarked.

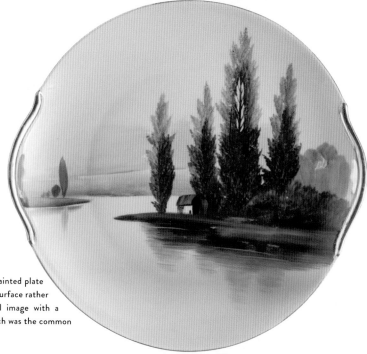

Made in Japan, this hand-painted plate utilizes the entire pictorial surface rather than surrounding a central image with a lush, festooned border, which was the common English style.

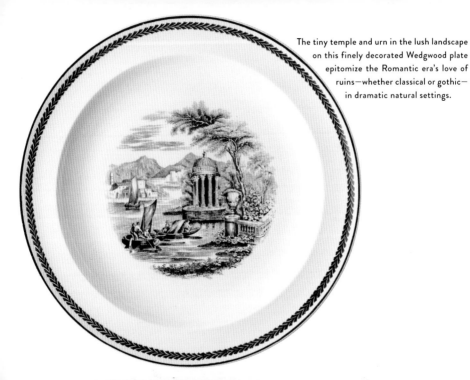

The tiny temple and urn in the lush landscape on this finely decorated Wedgwood plate epitomize the Romantic era's love of ruins—whether classical or gothic—in dramatic natural settings.

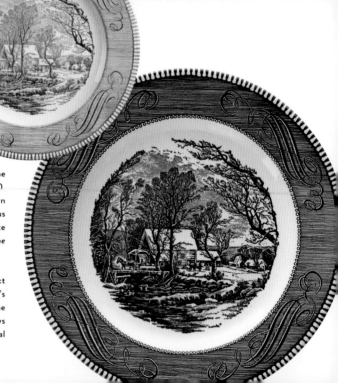

RIGHT: Royal China introduced the *Currier & Ives* pattern in about 1950. Each piece of dinnerware in this pattern uses an image based on one of the famous firm's lithographs. The dinner plate (shown here in red and blue) depicts *The Old Grist Mill*.

OPPOSITE: Imagine the cheerful effect of a table set with Royal Venton Ware's *Orlando* from the 1930s, on which the extremely colorful shoulder design plays off the bucolic landscape in the central reserve.

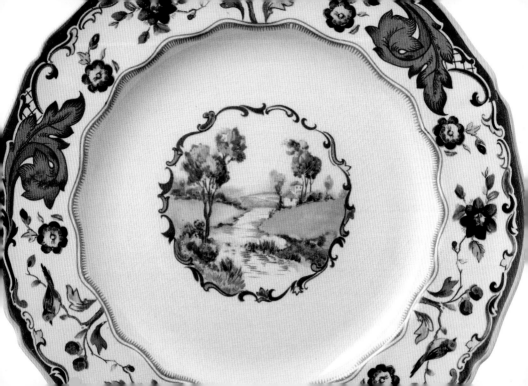

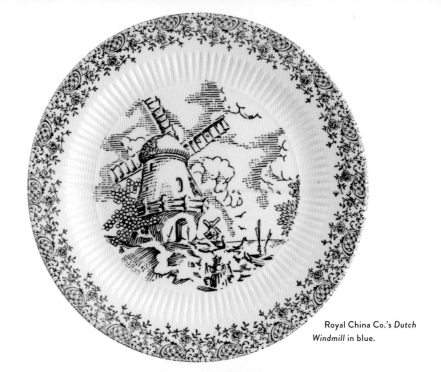

Royal China Co.'s *Dutch Windmill* in blue.

Each piece in a setting of Johnson Brothers' *Old Britain Castles*, introduced in 1930, is decorated with a different castle. The dinner plate (shown) depicts Blarney Castle.

In addition to plates celebrating the bucolic English countryside, manufacturers produced other, more exotic landscapes, such as these red transferware pieces. FROM LEFT TO RIGHT: William Adams & Sons' *Palestine*, circa 1850; Thomas Mayer's *Mogul Scenery*, circa 1826–35; and an unidentified English maker's *European Scenery*, also from the mid-nineteenth century.

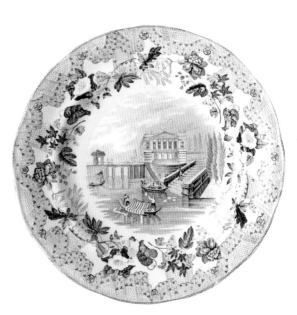

STORIED PLATES

From Shakespeare and Dickens to Joan of Arc and the Gibson Girl, classic designs inspired by classic stories.

Royal Doulton "Series Ware" celebrated significant people, places, events, and literary works in British history. Produced between 1919 and 1952, *Doctor Johnson* shows Samuel Johnson, the great eighteenth-century man of letters, at Ye Olde Cheshire Cheese, the landmark London pub established in 1538 that's still serving pints today.

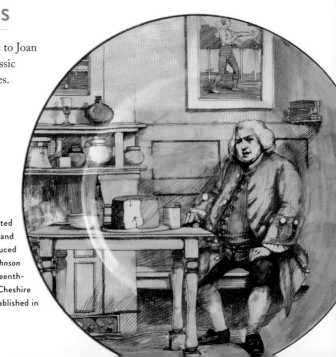

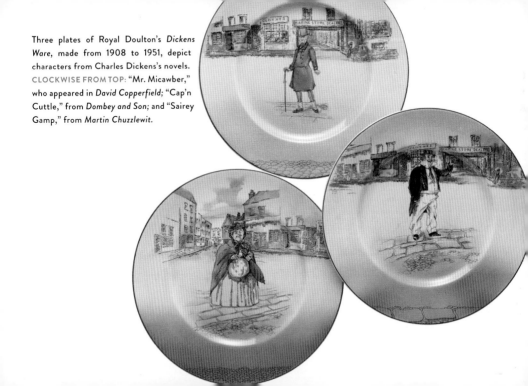

Three plates of Royal Doulton's *Dickens Ware*, made from 1908 to 1951, depict characters from Charles Dickens's novels. CLOCKWISE FROM TOP: "Mr. Micawber," who appeared in *David Copperfield*; "Cap'n Cuttle," from *Dombey and Son*; and "Sairey Gamp," from *Martin Chuzzlewit*.

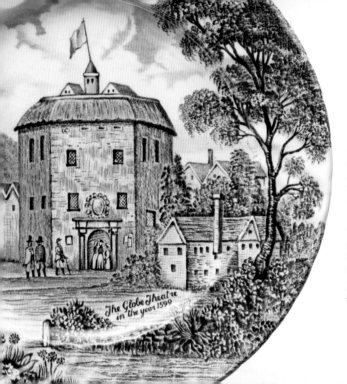

LEFT: *Shakespeare's Country*, a line of blue and white transferware by Royal Essex, depicts places related to the life of William Shakespeare. The salad plate shows London's Globe Theatre.

OPPOSITE: In the early 1900s Royal Doulton produced a twenty-four-plate series of scenes from Charles Dana Gibson's drawings for *A Widow and Her Friends*, one of the extremely popular stories that introduced the iconic all-American Gibson Girl to the world.

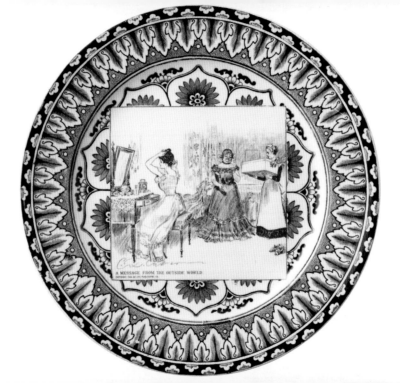

A MESSAGE FROM THE OUTSIDE WORLD

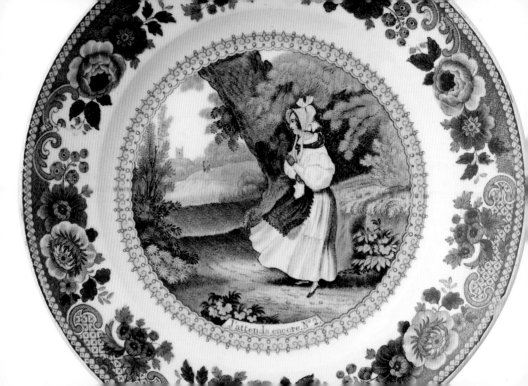

J'attends encore. No 2

OPPOSITE: This French hand-colored transferware dessert plate is titled "J'attends encore" (I'm still waiting). It's number 2 in a set of twelve showing humorous romantic situations, from Porcelaine Choisy, circa 1880.

RIGHT: An unusually grim black-and-white plate depicting the fiery death of Joan of Arc from a nineteenth-century French set illustrated with scenes from the life of the saint.

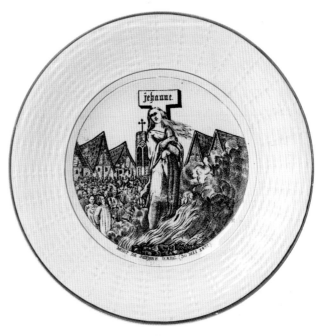

NEW ENGLAND LIFE

Artist and printmaker Clare Leighton spent three years researching and creating the woodblocks used to print the *New England Industries* series of twelve plates issued by Wedgwood in 1952.

GRIST MILLING

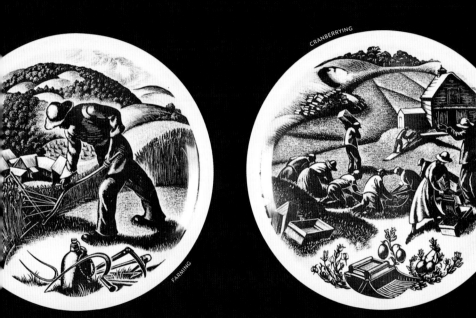

CRANBERRYING

FARMING

SOUVENIRS

When most travel was still a luxury and long before point-and-shoot cameras became a fact of life, taking home a memento of a visit was a popular custom. Today, pieces that depict something no longer in existence, such as a world's fair, are particularly valuable to collectors. Here, a series of unmarked souvenir plates.

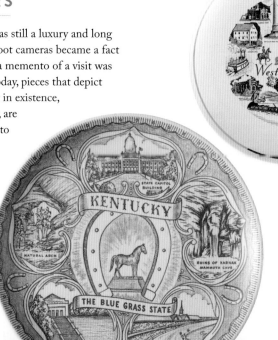

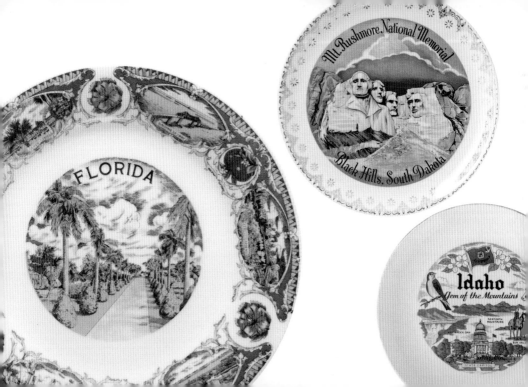

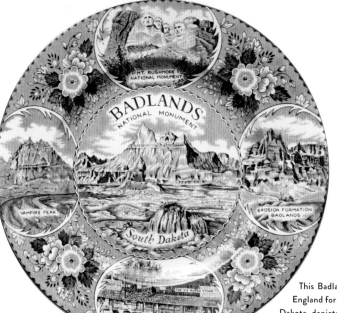

This Badlands plate was manufactured in England for sale at Wall Drug of Wall, South Dakota, depicted at the bottom of the rim as a tourist attraction in its own right.

A Canadian Mountie surveys his Rocky Mountain precinct on a plate whose rim is decorated with the coats of arms of Canada's ten provinces.

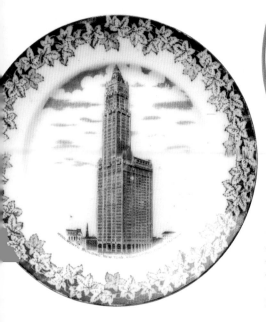

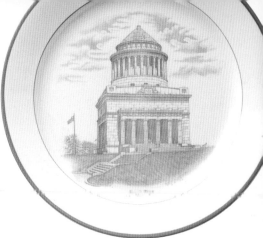

Four landmarks of New York City. The Woolworth Building, on a plate imported from Germany (LEFT); Grant's Tomb, on an unmarked plate (ABOVE); the Metropolitan Museum of Art, on Bavarian china (OPPOSITE, LEFT); and the Empire State Building, printed on Wedgwood's *Edme* shape plate (OPPOSITE, RIGHT).

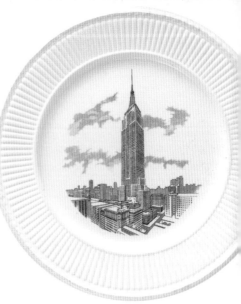

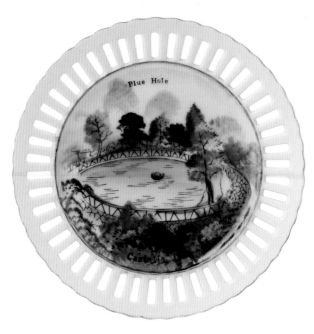

Blue Hole

Castalia

LEFT: From the 1920s until it was closed to the public in 1990, the Blue Hole in Castalia, Ohio, attracted up to 165,000 visitors a year. Just what was the attraction of this attraction? Not much, really. About seventy-five feet in diameter, the Hole radiated a vibrant blue hue and was believed, erroneously, to be bottomless.

OPPOSITE: This plate from Puerto Rico is a gorgeous example of the painter's art. Established in 1521 by Juan Ponce de León, legendary quester after the Fountain of Youth, San Juan is the oldest city in U.S. territory.

PUERTO RICO

CARIBE HILTON HOTEL

UNIVERSITY OF P.R.

CAPITOL BUILDING
SAN JUAN

HAUNTED SENTRY BOX

JOANNES EST nomen eius

JOANNES EST nomen eius

While technically not souvenirs, these plates all capture the spirit of the locale that inspired them. Fishs Eddy's *212* (BELOW), *Central Park* (RIGHT), and *Brooklyn* (OPPOSITE) all celebrate New York City.

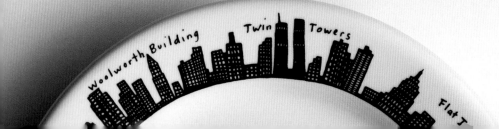

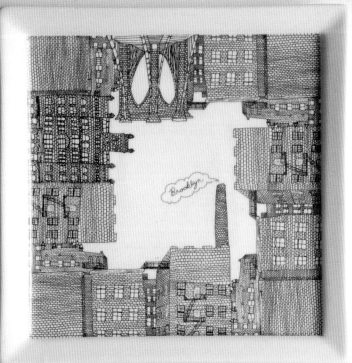

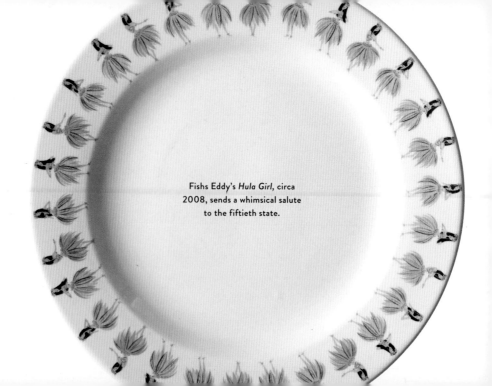

Fishs Eddy's *Hula Girl*, circa 2008, sends a whimsical salute to the fiftieth state.

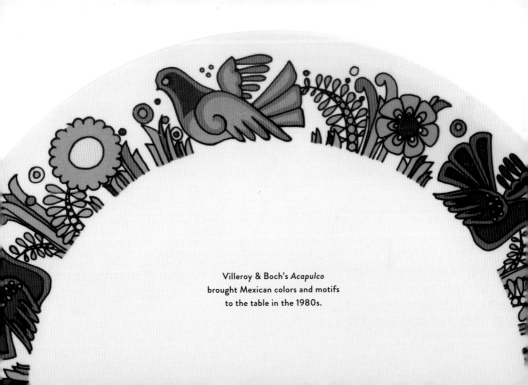

Villeroy & Boch's *Acapulco*
brought Mexican colors and motifs
to the table in the 1980s.

When it comes to city souvenirs, designers often like to cram all the landmarks onto the plate's surface rather than limit themselves to just one.

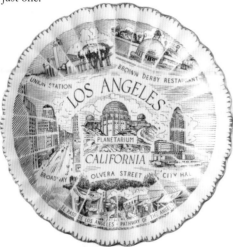

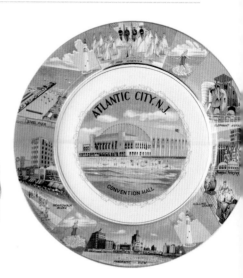

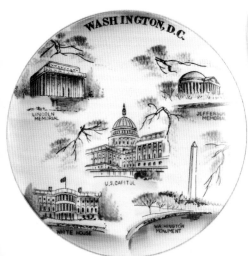

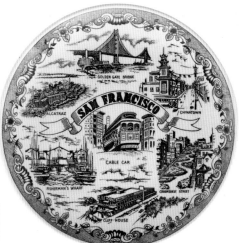

1939 WORLD'S FAIR

On April 30, 1939, the World's Fair opened in Flushing Meadows, Queens. Its optimistic slogan: BUILDING THE WORLD OF TOMORROW.

It was common for World's Fairs to celebrate some historic event, and New York's organizers settled on the 150th anniversary of Washington's inauguration in the city. Both are commemorated in the charmingly bizarre juxtaposition of imagery on this blue and white transfer-printed plate manufactured by the Lamberton Scammell China Company of Trenton, New Jersey.

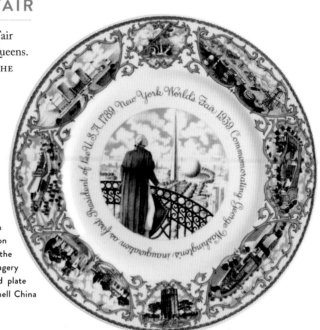

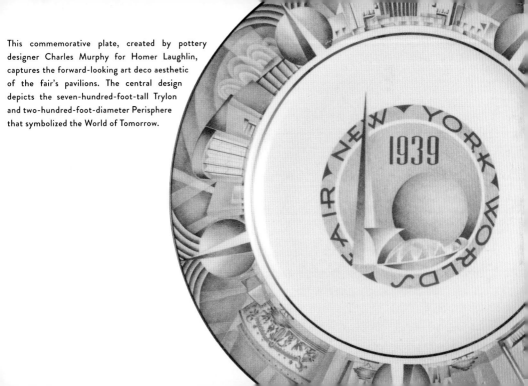

This commemorative plate, created by pottery designer Charles Murphy for Homer Laughlin, captures the forward-looking art deco aesthetic of the fair's pavilions. The central design depicts the seven-hundred-foot-tall Trylon and two-hundred-foot-diameter Perisphere that symbolized the World of Tomorrow.

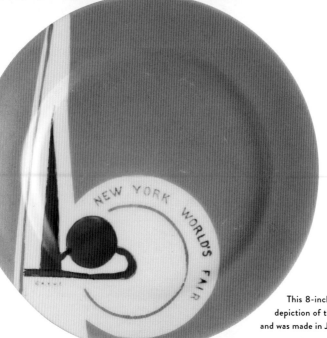

This 8-inch plate utilized a stylized
depiction of the Trylon and Perisphere
and was made in Japan.

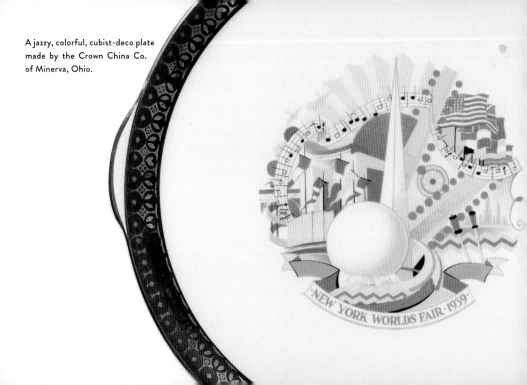

A jazzy, colorful, cubist-deco plate made by the Crown China Co. of Minerva, Ohio.

·NEW YORK WORLDS FAIR·1939·

RESTAURANT WARE

While some collectors want a restaurant piece for its nostalgic connection to a favorite haunt or as a souvenir from a famous spot, others just respond to the fun, graphic designs.

LEFT: A plate from the Homestead, a resort in Virginia's Allegheny Mountains.

ABOVE: Founded in 1953, Johnny's Dock in Tacoma, Washington, is still owned by the same family.

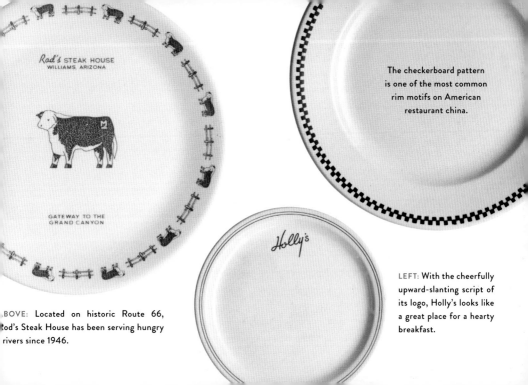

Rod's STEAK HOUSE
WILLIAMS, ARIZONA

GATEWAY TO THE
GRAND CANYON

The checkerboard pattern
is one of the most common
rim motifs on American
restaurant china.

Holly's

ABOVE: Located on historic Route 66,
Rod's Steak House has been serving hungry
rivers since 1946.

LEFT: With the cheerfully
upward-slanting script of
its logo, Holly's looks like
a great place for a hearty
breakfast.

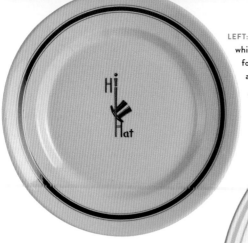

LEFT: With its connotations of insider exclusivity, Hi Hat, which is both slang for a top hat and a musician's term for a set of mounted cymbals that can be struck with a foot pedal, was the perfect name for a hip 1930s jazz club.

RIGHT: Landmark was a popular name for many diners on roadsides across the nation.

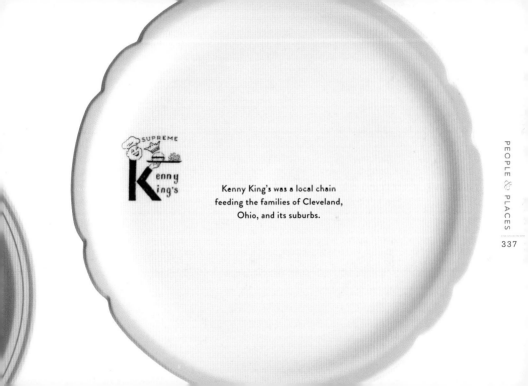

Kenny King's was a local chain feeding the families of Cleveland, Ohio, and its suburbs.

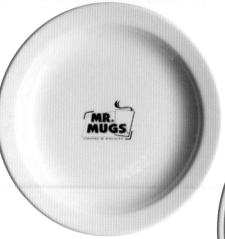

ABOVE: Mr. Mugs was a chain of doughnut shops in Ontario, Canada.

RIGHT: The comical, toque-wearing chef on this side plate, for a restaurant called Fosters, promises a tasty meal.

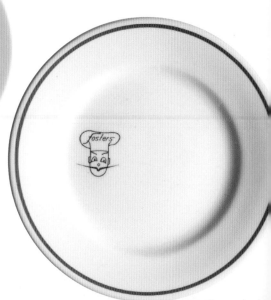

For nearly fifty years, from 1952 until 2000, Stickney's Hick'ry House was a beloved local chain in the Bay Area of Northern California.

1

2

3

4

5

6

1. The hospitable logo of Morrison's cafeterias, founded in Mobile, Alabama, in 1920, was once a welcoming sight all over the southeastern United States.

2. Deering, "the cream of creams," was an ice cream maker based in Portland, Maine, from 1886 until the 1990s.

3. The beefeater logo of the Mayfair Lounge is a common evocation of English hospitality.

4. Bearing another common name, this Midway restaurant plate could be from Massachusetts, Kentucky, or Utah.

5. From 1912 to 1981 Bernstein's Fish Grotto in San Francisco was famous for its entrance, a full-size ship's prow jutting out over the sidewalk.

6. Housed in an opulently appointed converted sheep barn in Central Park from 1976 until 2009, Tavern on the Green symbolized New York glamour and romance to generations of Big Apple natives and tourists alike.

7. A gilded decorative charger, or service plate, evokes the oil-rich opulence of the Petroleum Club of Midland, Texas.

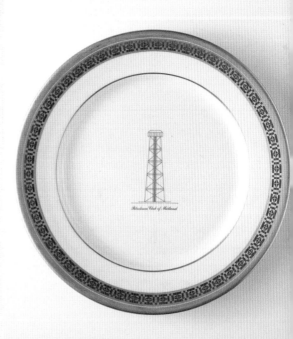

These three plates display the mysterious emblems
of unknown private clubs and corporations.

NO PLACE LIKE HOME

Domestic comforts are perhaps best depicted on that most domestic of objects.

RIGHT: Royal China of Sebring, Ohio, introduced *Colonial Homestead* in 1950.

OPPOSITE: Homer Laughlin launched *Colonial Kitchen* in 1937.

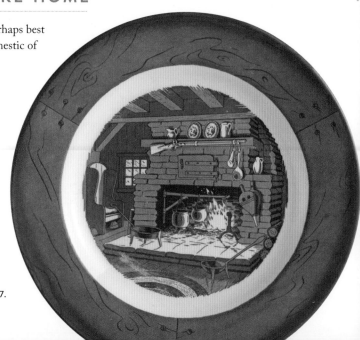

OPPOSITE: Ridgway Pottery's *Homemaker* (1957) was inspired by the trendy contemporary furniture that the plate's designer, Enid Seeney, saw in London shops.

RIGHT: "Terrace," from Fishs Eddy's *Floor Plan* collection.

WEDGWOOD

Born into a family of Staffordshire potters in 1730, by the age of six Josiah Wedgwood was learning the trade in his grandfather's shop. An experimenter throughout his life, his creamware (see page 44) earned him a royal warrant as potter to King George III and Queen Charlotte. And his Black Basalt (see page 86) and Jasperware pieces epitomize neo-classical style.

But Wedgwood's achievements weren't just in the studio. In the 1760s he began exporting his china to continental Europe and North America, and in 1766 he opened a state-of-the-art factory, where he introduced streamlined production methods that sped up and increased output. Wedgwood was also a mastermind at marketing his products. He created catalogues, opened a fashionable showroom in London, solicited endorsements from tastemakers and aristocratic patrons, and commissioned designs from the era's leading artists—all to entice middle-class buyers.

After his death in 1795 the company continued quietly for several generations. In 1986 it merged with Waterford Glass to form the Waterford Wedgwood Group. As of 2009, the company had moved all manufacturing from England to a new facility in Indonesia.

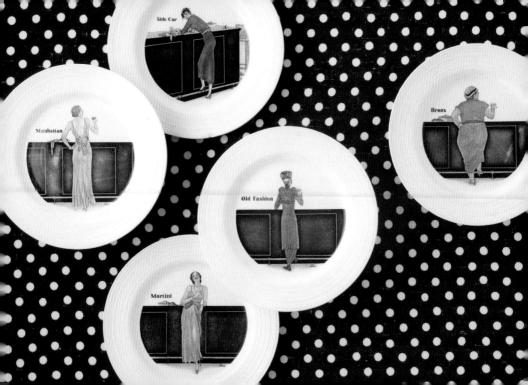

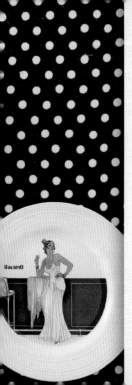

HOLIDAYS & CELEBRATIONS

OLIDAYS AND SPECIAL EVENTS have always been occasions for celebratory meals, and such meals often call for special dishes. Today, a holiday party might prompt the host or hostess to pick up a package of cute paper plates, but the first special-occasion tablewares were extremely expensive porcelain sets made for dessert.

For a long time, sugar was such a rare and expensive commodity that sweets were often served on their own unique dishes. While there is some evidence that French royalty began to eat what looks like the modern dessert course in the fifteenth century, it probably wasn't until the late seventeenth century that the serving of sweets at the conclusion of the meal was standardized. This dining innovation, however, occurred only at the highest tier of society. (Indeed, sugar remained a luxury item for most people well into the nineteenth century.)

After a big feast in the 1600s, guests would withdraw from the main dining table to be served spiced wine and other delicacies while the great hall was set up for post-dinner activities. This custom came to be called "dessert," from the French verb *desservir* (to clear away). In some grand English houses this indulgent treat, called a banquet, was served in a special room built solely for this purpose—sometimes even in the garden or on the roof. Many such pavilions were created from tents or

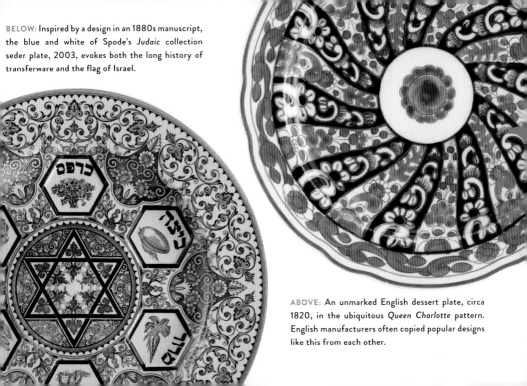

BELOW: Inspired by a design in an 1880s manuscript, the blue and white of Spode's *Judaic* collection seder plate, 2003, evokes both the long history of transferware and the flag of Israel.

כרפס

מרור

חזרת

ABOVE: An unmarked English dessert plate, circa 1820, in the ubiquitous *Queen Charlotte* pattern. English manufacturers often copied popular designs like this from each other.

ephemeral materials like logs, branches, and flowers to commemorate a special occasion. It is easy to imagine the delight of guests climbing a spiral staircase or trekking into a torchlit garden to find themselves in a tiny, enchanted, exquisitely decorated bower filled with an extravagant display of sweets and fruits. *The English Housewife,* a cookbook and domestic manual of 1615, lists recipes appropriate for "banqueting stuff," including quince paste and cakes, orange marmalade, gingerbread, cheeses, spice cakes, "marchpane" (marzipan), fruit and flower conserves, baked apples, pears, and wafers.

Of course, these banqueting houses had their own unique furnishings and special dishware. Some small wooden "fruit trenchers" from the Elizabethan and Jacobean eras survive in museum collections. They are often decorated with pictures of fruit or amusing illustrations and epigrams,

in keeping with the more relaxed, lighthearted atmosphere of the dessert course.

When first introduced, porcelain, though fragile and expensive, was seen as less formal than silver and silver-gilt dishes. Painted with delicate flowers and bucolic landscapes or molded into unusual shapes, it was deemed perfect for the dessert course. (It took aristocrats a very long time to give up their precious metal plates at the formal dinner.) But there was also a practical consideration: Acidic fruit juices interact with metal, which negatively affects the taste.

While dessert may have been the original special occasion that required its own dishes, it didn't take long for people to realize that myriad events could be enhanced by their own unique services. In the nineteenth century

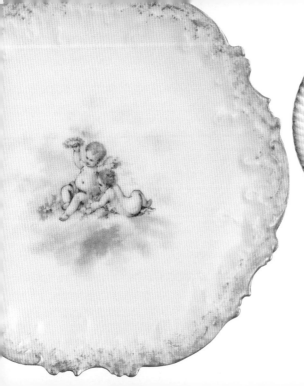

LEFT: Limoges dessert plate with scalloped rim and hand-colored putti, circa 1890.

ABOVE: Delicate pink shell-shaped dessert plate from Wedgwood, circa 1830.

English manufacturers catered to Americans with turkey dishes for Thanksgiving. Christmas china appeared in the early to mid-twentieth century. *Ladies' Home Journal* praised paper plates in an 1885 issue. These days, disposable plates for birthdays, Halloween, baby showers, graduation parties, and many other celebratory situations are far more common than porcelain, so many people collect china dessert services from the eighteenth and nineteenth centuries as relics of a more genteel time. But twentieth-century paper plates can inspire their own kind of nostalgia.

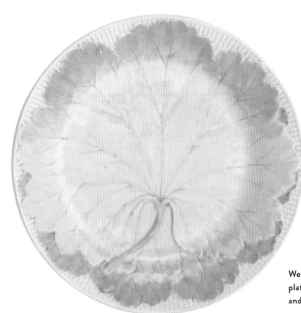

Wedgwood leaf-shaped dessert
plates produced between 1820
and 1860.

SPECIAL OCCASIONS

A unique dish makes any event a festive
celebration.

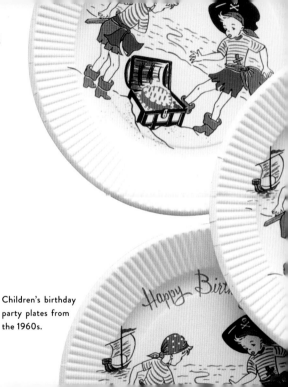

Children's birthday
party plates from
the 1960s.

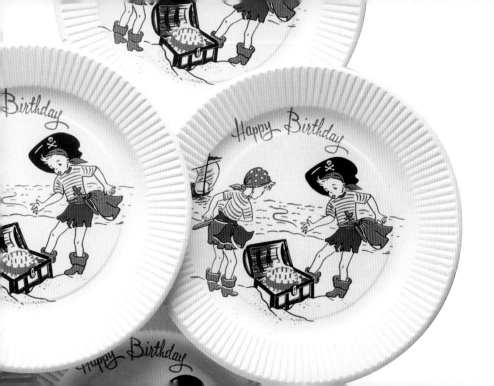

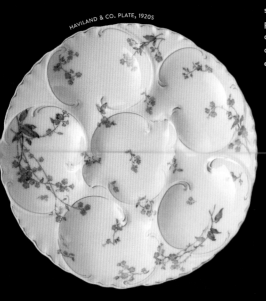

HAVILAND & CO. PLATE, 1920S

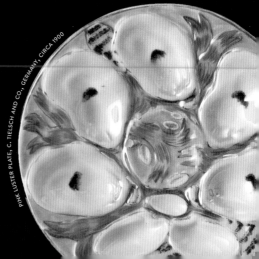

PINK LUSTER PLATE, C. TIELSCH AND CO., GERMANY, CIRCA 1900

Well into the nineteenth century, oysters were a dietary staple for all social classes, but by the 1860s overfishing and pollution had driven up prices and turned them into a luxury only the wealthy could afford. At this time, the special oyster plate made its appearance and helped transform the eating of a few of the delicacies into an aesthetic indulgence.

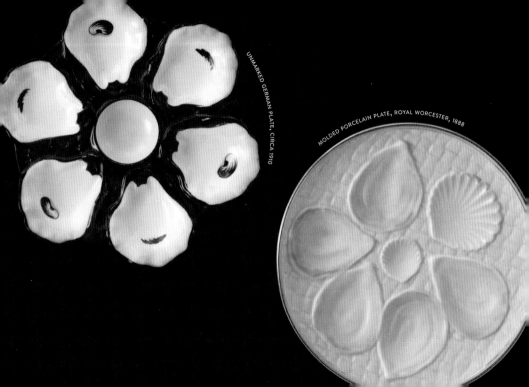

UNMARKED GERMAN PLATE, CIRCA 1910

MOLDED PORCELAIN PLATE, ROYAL WORCESTER, 1888

Hand-painted, tin-glazed earthenware pieces made to commemorate the Palio, a horse race held every summer in the central square of Siena, Italy, since 1656.

RIGHT: Following the repeal of Prohibition in 1933, the cocktail party became a popular way to entertain at home. To deter utter intoxication, cocktails require snacks, and snacks, of course, require plates. To fill the void in the marketplace, Crown Ducal produced this set on which each cocktail is personified by a woman, such as "Manhattan," shown.

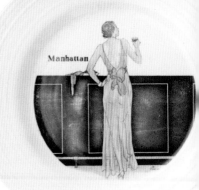

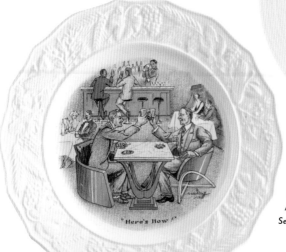

LEFT: "Here's How!" from Fondeville Ambassador Ware's *International Toasts Series*, 1933.

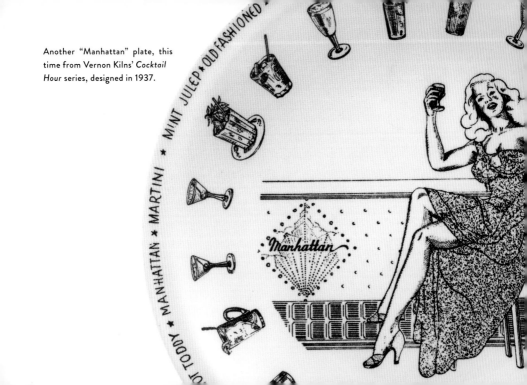

Another "Manhattan" plate, this time from Vernon Kilns' *Cocktail Hour* series, designed in 1937.

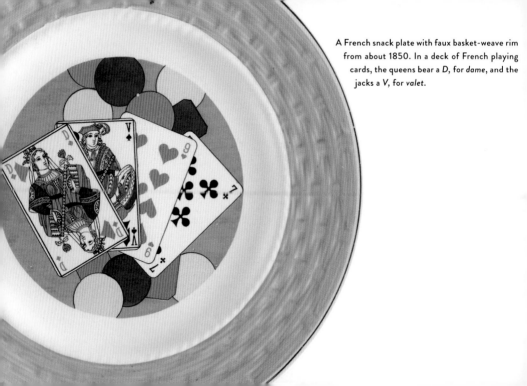

A French snack plate with faux basket-weave rim from about 1850. In a deck of French playing cards, the queens bear a *D*, for *dame*, and the jacks a *V*, for *valet*.

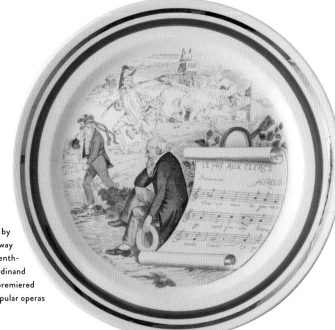

An evening of live music followed by refreshments was once a common way to entertain guests. This mid-nineteenth-century French plate illustrating Ferdinand Hérold's *Le Pré aux Clercs*, which premiered in 1832, is part of a set depicting popular operas by various composers.

Produced in the 1940s, some *Woodfield* snack plates from the Steubenville Pottery Company have a small indentation to hold an accompanying cup—perfect for carrying goodies back to your seat at a buffet party.

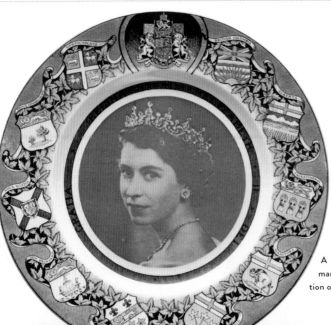

A plate made for the Canadian market to celebrate the coronation of Queen Elizabeth II in 1953.

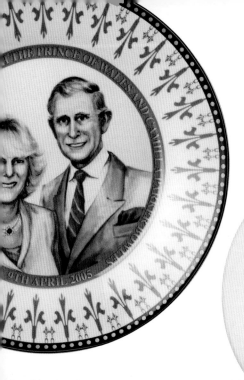

LEFT: A plate issued by London's *Daily Express* in honor of the wedding of Prince Charles to Camilla Parker Bowles on April 9, 2005.

BELOW: Imitating blue and white Delftware, this plate was used to serve a 2009 feast held on New York City's Governor's Island to celebrate the four-hundredth anniversary of Henry Hudson's arrival at the mouth of the Hudson River in September 1609.

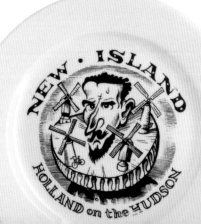

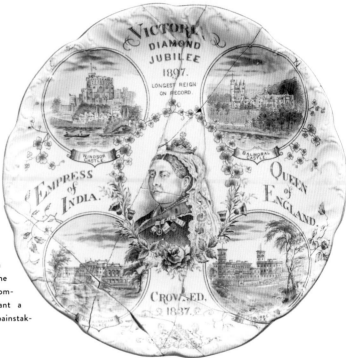

A souvenir of the celebrations held in honor of Queen Victoria's sixtieth year on the British throne in 1897, this commemorative plate clearly meant a great deal to the person who painstakingly glued it back together.

TO COMMEMORATE THE 400TH ANNIVERSARY OF THE BIRTH OF WILLIAM SHAKESPEARE.

In 1964 Royal Doulton produced this limited-edition plate decorated with the famous engraved portrait from Shakespeare's *First Folio* to commemorate the four-hundredth anniversary of the Bard's birth.

HALLOWEEN

Inspiring waves of nostalgia, vintage paper decorations for Halloween parties are hugely collectible. Unfortunately, it can be nearly impossible to accurately date these objects unless they are sold in their original packaging.

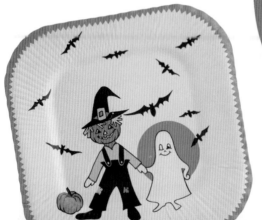

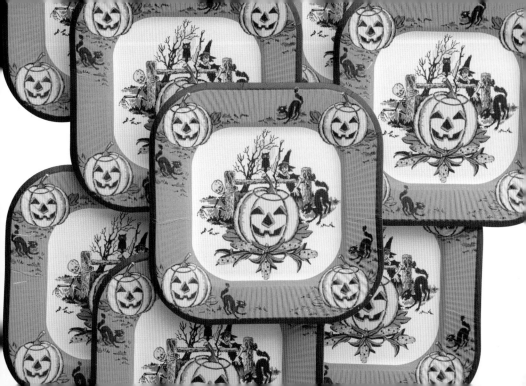

THANKSGIVING

When Thanksgiving became a national holiday in 1863, English manufacturers rushed to provide the fine sets of dishes required for such a feast.

Johnson Brothers' Windsorware *Native American*, also known as the *Standing Turkey* pattern, was manufactured from the early 1950s through the early 1970s.

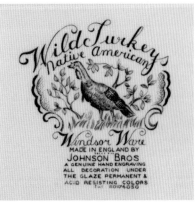

The backstamp for *Native American*
is a work of art in itself.

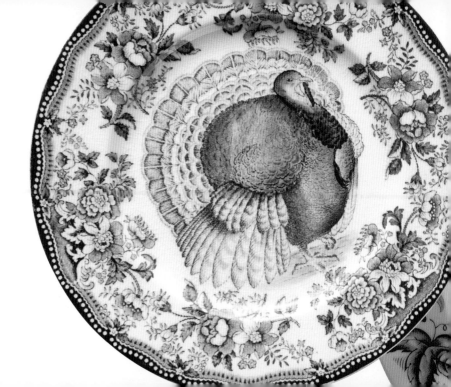

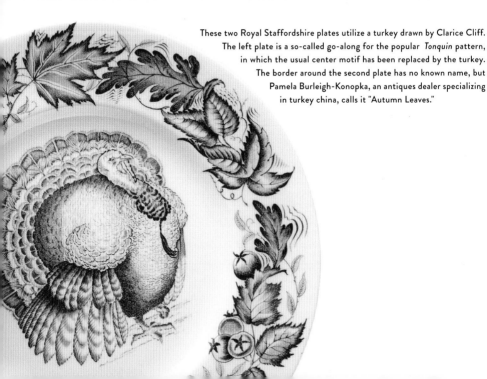

These two Royal Staffordshire plates utilize a turkey drawn by Clarice Cliff. The left plate is a so-called go-along for the popular *Tonquin* pattern, in which the usual center motif has been replaced by the turkey. The border around the second plate has no known name, but Pamela Burleigh-Konopka, an antiques dealer specializing in turkey china, calls it "Autumn Leaves."

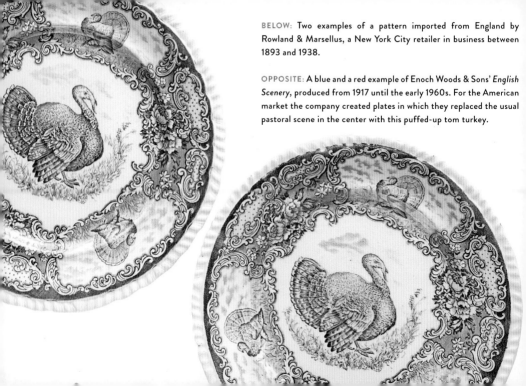

BELOW: Two examples of a pattern imported from England by Rowland & Marsellus, a New York City retailer in business between 1893 and 1938.

OPPOSITE: A blue and a red example of Enoch Woods & Sons' *English Scenery*, produced from 1917 until the early 1960s. For the American market the company created plates in which they replaced the usual pastoral scene in the center with this puffed-up tom turkey.

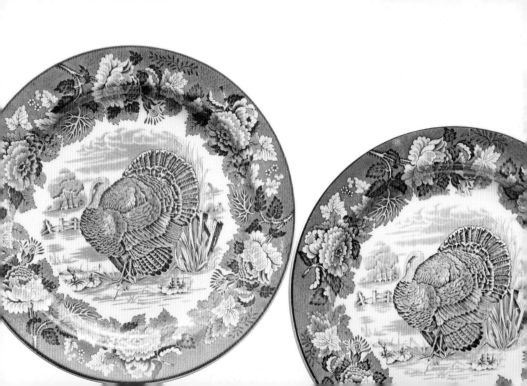

CHRISTMAS

It may be hard to believe, but no dinnerware for Christmas existed before 1938, when Spode's *Christmas Tree* made its debut. Now, no yuletide feast feels quite so festive without its own dedicated set of dishes.

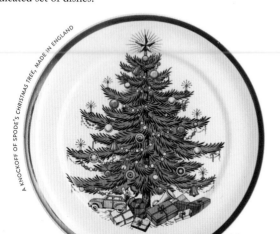

A KNOCKOFF OF SPODE'S *CHRISTMAS TREE*, MADE IN ENGLAND

JOHNSON BROTHERS' *MERRY CHRISTMAS* (1959)

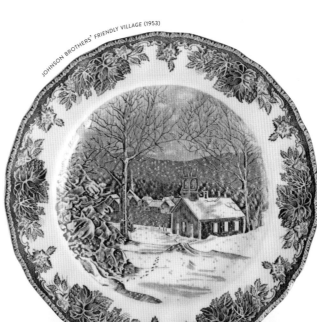

JOHNSON BROTHERS' FRIENDLY VILLAGE (1953)

POINSETTIA, BY BLOCK CHINA

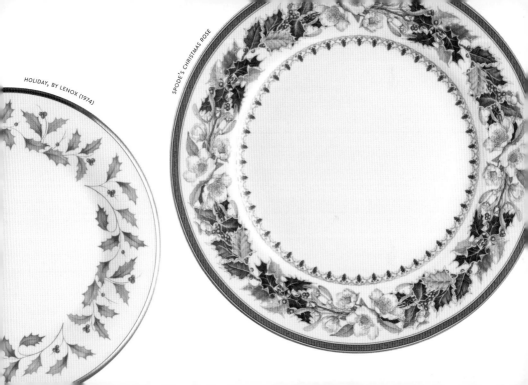

HOLIDAY, BY LENOX (1974)

SPODE'S CHRISTMAS ROSE

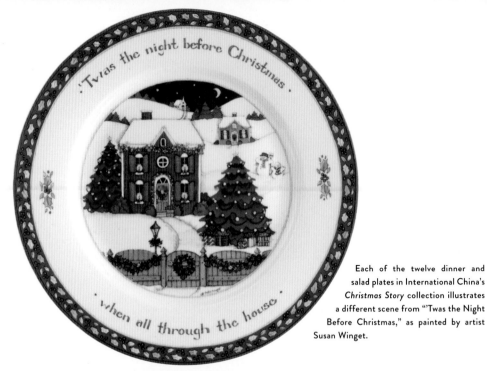

"'Twas the night before Christmas .

. when all through the house .

Each of the twelve dinner and salad plates in International China's *Christmas Story* collection illustrates a different scene from "'Twas the Night Before Christmas," as painted by artist Susan Winget.

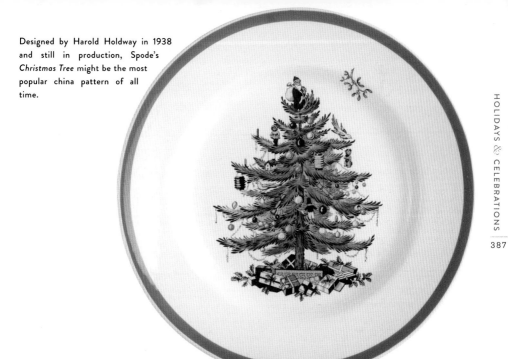

Designed by Harold Holdway in 1938 and still in production, Spode's *Christmas Tree* might be the most popular china pattern of all time.

CHILDREN'S PLATES

Giving kids their own dishes is a sure way to get them excited about mealtime— they make every dinner a party.

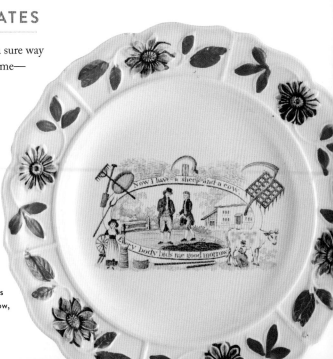

Moralistic tales and ethical reminders decorate many an object made for children. This circa 1850 plate features scenes from a productive farm and bears the saying "Now I have a sheep and a cow, Every body bids me good morrow."

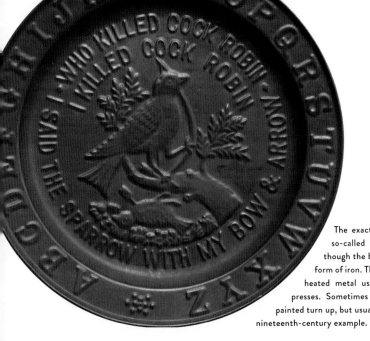

The exact composition of the metal of so-called tin plates remains a mystery, though the base of most pieces is actually a form of iron. The design results from stamping heated metal using large, extremely powerful presses. Sometimes metal plates that have been painted turn up, but usually they are uncolored, like this nineteenth-century example.

A PRESENT FOR A GOOD BOY

Although the images on these two circa 1830 plates aren't especially childlike, the plates' small size (6½ inches across) and dedicatory banners indicate that they were indeed intended for children.

A TRIFLE for my DEAR NIECE

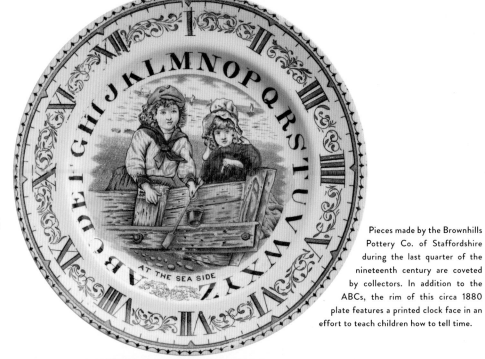

AT THE SEA SIDE

Pieces made by the Brownhills Pottery Co. of Staffordshire during the last quarter of the nineteenth century are coveted by collectors. In addition to the ABCs, the rim of this circa 1880 plate features a printed clock face in an effort to teach children how to tell time.

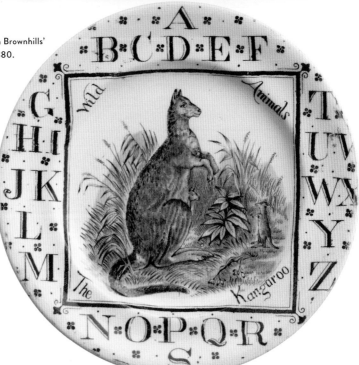

"The Kangaroo," from Brownhills'
Wild Animals, circa 1880.

This "Sunbonnet Girl" plate from Roseville Pottery's *Juvenile* line was based on the best-selling work of artist Bertha L. Corbett. *The Sun-bonnet Babies* featured the antics of a group of three little girls whose faces are always obscured behind their enormous hats.

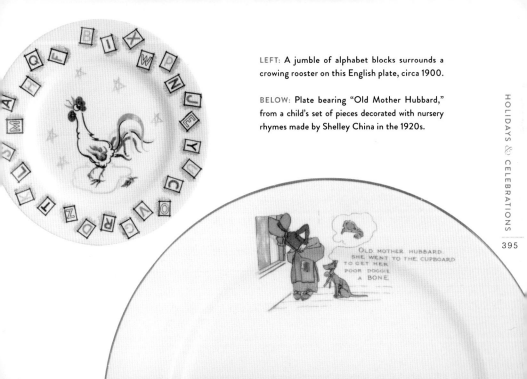

LEFT: A jumble of alphabet blocks surrounds a crowing rooster on this English plate, circa 1900.

BELOW: Plate bearing "Old Mother Hubbard," from a child's set of pieces decorated with nursery rhymes made by Shelley China in the 1920s.

OLD MOTHER HUBBARD
SHE WENT TO THE CUPBOARD
TO GET HER
POOR DOGGIE
A BONE.

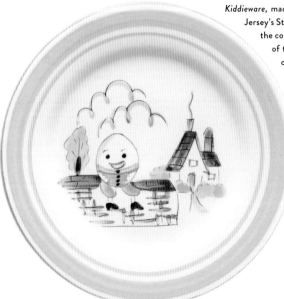

Kiddieware, made in various patterns by New Jersey's Stangl Pottery between 1941 and the company's demise in 1978, is one of the most collectible categories of children's ware on the market today. Pictured here, FROM LEFT TO RIGHT: *Flying Saucer*, *Ginger Cat*, and *Humpty Dumpty*.

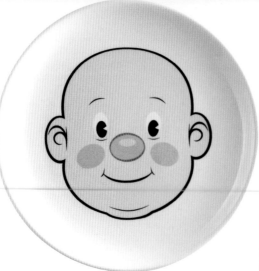

BELOW: Vitreous china "feeding plate" with scenes from *Little Red Riding Hood*, made by the Sterling China Company of Ohio in the 1960s.

OPPOSITE: *Pets' Farm* plate, part of a set including a bowl and a mug, was made by Copeland Spode in the 1960s.

ABOVE: Is it a toy or a plate? *Food Face*, designed by Jason Amendolara in 2009, subversively demands that kids play with their food. Even the most straitlaced adult has to give in.

Though not designed specifically for kids, Jane Jenni's colorful, graphic, and plastic punning rebus plates, introduced in 2007, are perfect for the tots' table.

my

little

sweet

NORITAKE

The Japanese china company now known as Noritake grew out of the Morimura Brothers trading company, established in New York in 1876 to import gift items from Japan. At some point they started supplying blanks (unpainted ceramic pieces) to independent china painters, which led the brothers to open their own china-decorating workshop in Japan.

In 1904 the brothers opened a porcelain factory in the village of Noritake, Japan, but it took another ten years to create dinnerware that they deemed good enough to export. But when they were ready, the company aggressively advertised its collection—with some of the first full-color ads for dinnerware—and the range of its products could soon be found in high-end department stores and budget-minded five-and-dimes.

Of course, World War II took a huge toll on Noritake's business. The factory was damaged by Allied bombing, and many of its records were destroyed. In 1946 the company began marketing to U.S. consumers under the name "Rose China," but by 1953 the name Noritake, and a new backstamp, an "N" inside a wreath, once again proudly proclaimed the Japanese origins of their fine products. Today, Noritake is one of the largest manufacturers of china in the world, and its wares are distributed in more than a hundred countries.

AZALEA

APPENDIX A
100 MOST POPULAR PATTERNS

Since opening shop in 1981 Replacements, Ltd., now the world's largest dealer in old and new china, crystal, and silver, has been tracking patterns purchased or simply requested by customers. After more than three decades of collecting data from nearly 11 million users, Replacements shares with us here the 100 most requested patterns from their database.

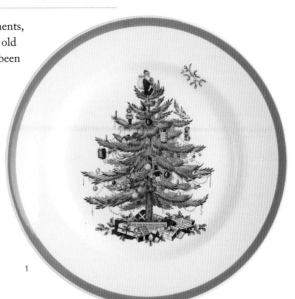

1

1. Spode, *Christmas Tree*

2. Lenox, *Holiday*

3. Franciscan, *Desert Rose* (USA backstamp)

4. Royal Albert, *Old Country Roses*

5. Portmeirion, *Botanic Garden*

10

11

12

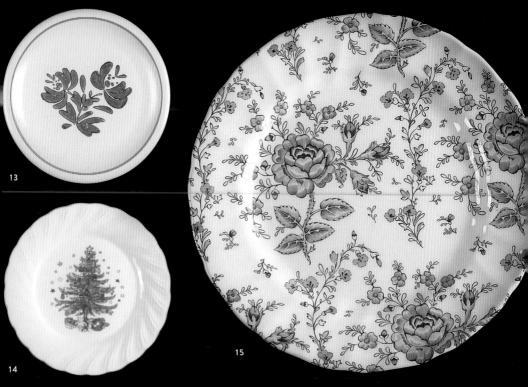

13

14

15

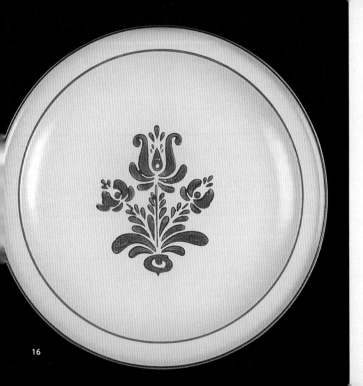

13. Pfaltzgraff, *Yorktowne*

14. Nikko, *Happy Holidays*

15. Johnson Brothers, *Rose Chintz* in pink

16. Pfaltzgraff, *Village*

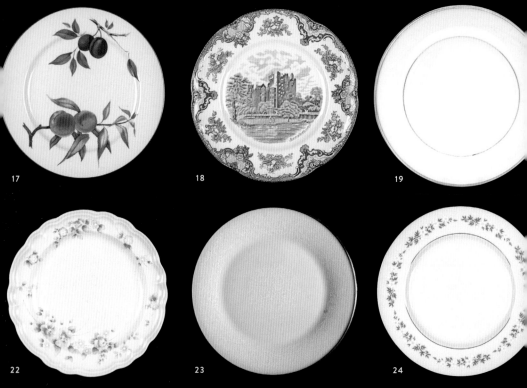

17

18

19

22

23

24

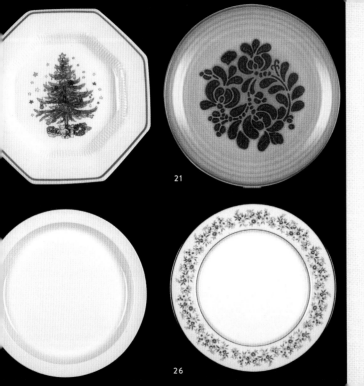

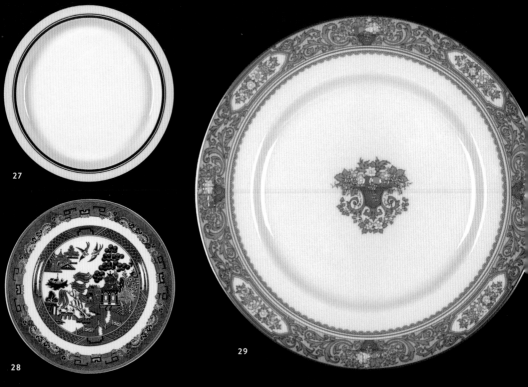

27

28

29

27. Dansk, *Christianshavn Blue*

28. Johnson Brothers, *Willow Blue*

29. Lenox, *Autumn*

30. Mikasa, *Garden Harvest*

31. Homer Laughlin, *Fiesta* in cobalt

32. International, *Heartland*

33. Haviland, *Rosalinde*

34

35

36

38

40

41.

42

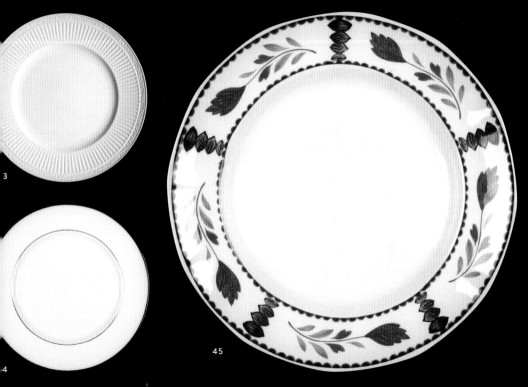

3

4

45

46

47

50

46. Johnson Brothers, *Heritage* in white

47. Pfaltzgraff, *Winterberry*

48. Franciscan, *Apple* (England backstamp)

49. Pfaltzgraff, *Heritage* in white

50. Staffordshire, *Liberty Blue*

51. Wedgwood, *Edme*

52. Mikasa, *French Countryside*

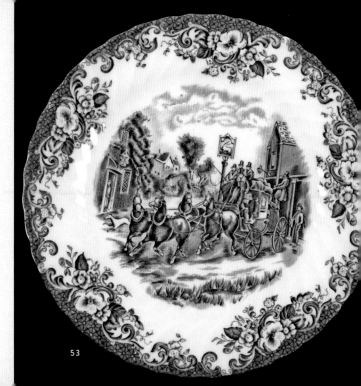

54

55

56

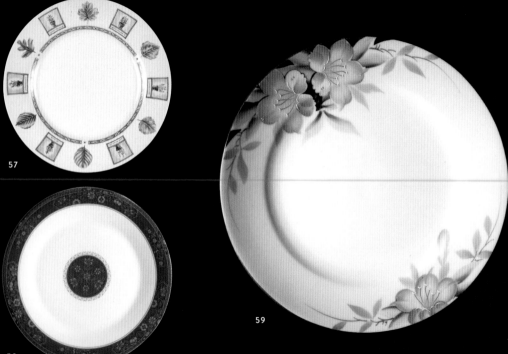

57

58

59

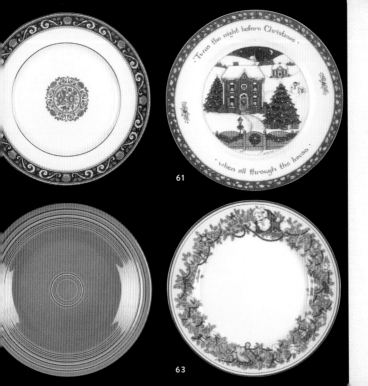

57. Lenox, *Naturewood*

58. Royal Doulton, *Carlyle*

59. Noritake, *Azalea*

60. Wedgwood, *Runnymede* in blue

61. International, *Christmas Story*

62. Homer Laughlin, *Fiesta* in persimmon

63. Fitz and Floyd, *St. Nicholas*

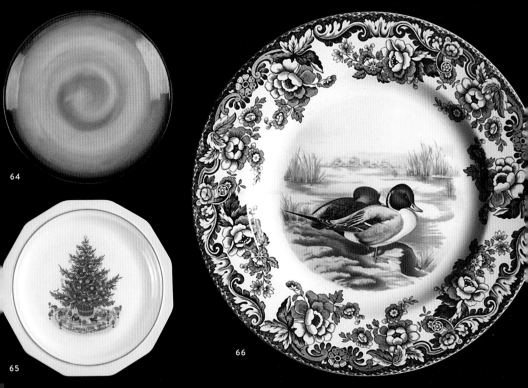

64

65

66

64. Sango, *Nova* in brown

65. Pfaltzgraff, *Christmas Heritage*

66. Spode, *Woodland*

67. Lenox, *Castle Garden*

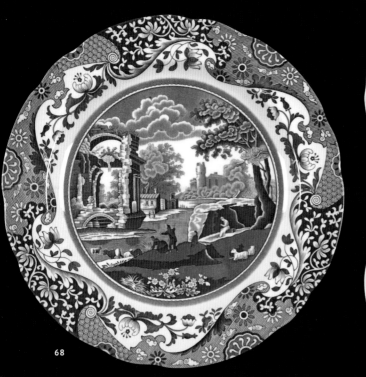

68

69

72

71

74

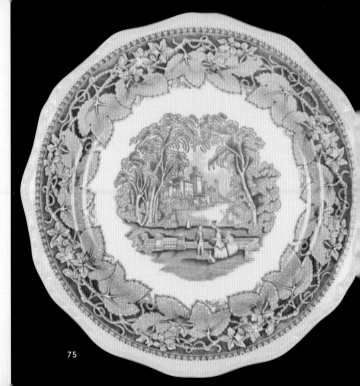

75

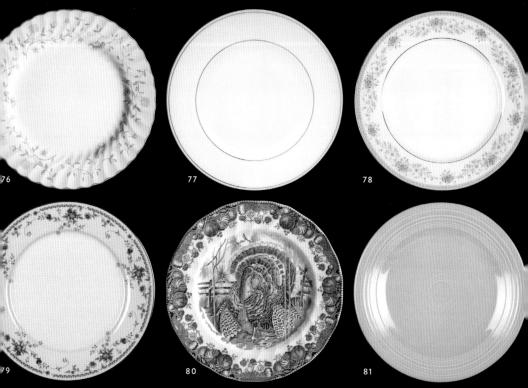

76

77

78

79

80

81

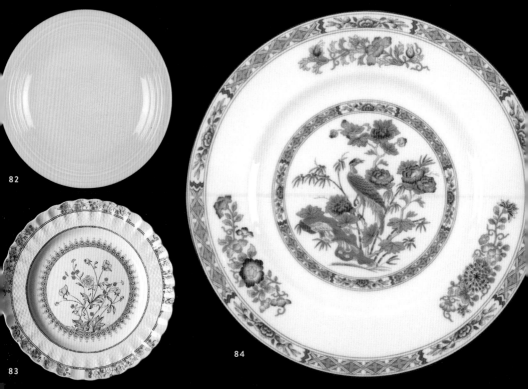

82

83

84

82. Homer Laughlin, *Fiesta* in sunflower

83. Spode, *Buttercup*

84. Wedgwood, *Kutani Crane*

85. Villeroy & Boch, *Amapola*

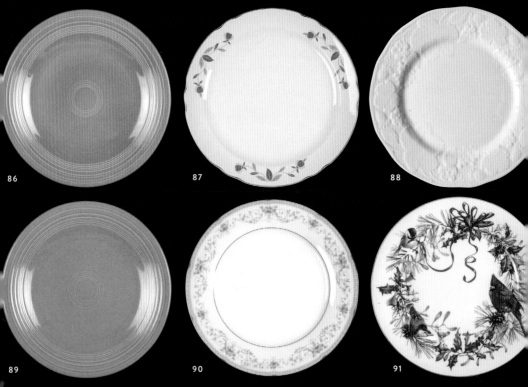

86

87

88

89

90

91

93

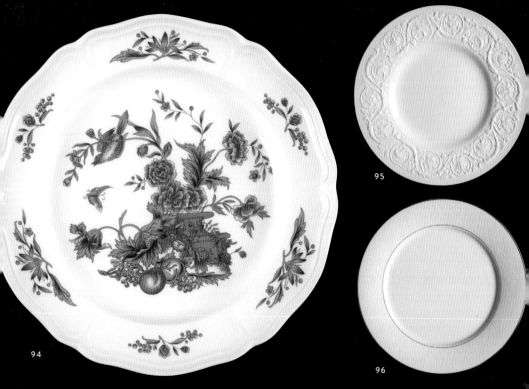

94

95

96

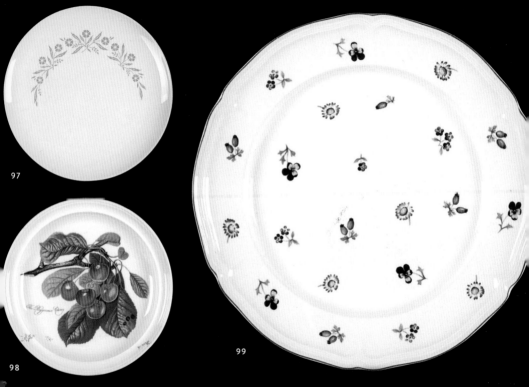

97

98

99

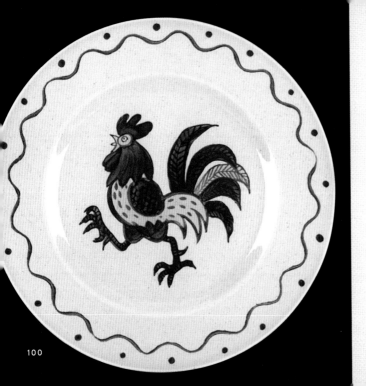

100

APPENDIX B
TIPS FOR COLLECTORS

When you first begin collecting plates, don't get too hung up on maker's marks. As Clarence Cook advised in his 1881 book *The House Beautiful,* "It does not do . . . in china, any more than in pictures, to go by names. Go by what is pretty." So start with what makes your heart sing, then consider condition. If you're really interested in building value, pass up pieces with nicks, cracks, repairs, or crazing (a network of tiny cracks in the glaze), unless it's an extremely rare item in a particular pattern that you already collect. Unless you just love it, that is—you never know when you'll find something that you have to have no matter what. Whether you are looking for sets to use on the table or individual pieces to hang on the wall or set on a shelf, there are definitely plates to fit your personal style. Below, some more tips for collecting and living with dishes.

DECODING DISHES

While backstamps can provide a great deal of information, they won't tell you much about value, which depends on condition and rarity. Here are some guidelines:

- In the United States, when a plate bears the name of its country of origin, it was probably made after 1890, when the McKinley Tariff required such marks on imports. To make the meaning clearer, customs laws mandated the addition of the phrase "Made in . . ." from 1914 on.
- By far the majority of nineteenth-century pieces you'll find were made in England. The

word *trademark* usually indicates an English piece made from 1855 on. The letters *LTD,* indicating a form of incorporation, were added to many English company names starting in 1880.

- Japan has long been another big source of ceramics in the U.S. marketplace. Pieces marked *Nippon* ("Japan" in Japanese) were made prior to 1921, when Congress decreed that the country's imports be marked *Japan.*

- A company label can range from one word to an elaborate design that almost trumps the front of the plate (see page 377, for example). Some logos are raised, while some are stamped into the clay. Most are simply printed onto the body and then covered by the glaze.

- Company logos and backstamps change over time, or with new ownership, and these changes provide clues as to approximately when an object was produced.

- The name on the back may identify the pattern, but very often it refers to the plate shape. In the twentieth century, many companies kept track of the shapes they produced, which were then decorated with any number of patterns. (For example, Homer Laughlin's Virginia Rose shape can be found with some 150 unique patterns, but all pieces only say "Virginia Rose.")

- Numbers on the back may contain information about the date or location of production. Such systems vary from factory to factory, so it's impossible to generalize. If you find yourself amassing pieces by one manufacturer, consult one of the many specialist books devoted to it.

- Many pieces aren't marked. If you're curious to know how a dealer has identified a maker or a pattern, ask!

WASHING DISHES

Aside from dishpan hands, the true horror of dishwashing is that beloved glasses and dishes are easily broken. While most dishes today, even fine china, are made to be dishwasher safe (just don't use too much soap—it can leave residue), older plates need a little more TLC. Plates decorated with gold, metallic lustre, or hand-painting—all of which are applied on top of the glaze and thus are more prone to being scratched or rubbed off—and dishes that are cracked, crazed, or repaired should always be washed by hand, and never in extremely hot water. Even such modern colored pieces as Bauer *Ringware* or *Fiesta* from the 1930s should never be put in the dishwasher, which can damage the glaze.

Ordinary dish soap and sponges are fine for most plates. If a piece is chipped or cracked, avoid submerging it entirely in water. Instead, try to remove dirt with a dry cotton swab or a soft brush. Then use mildly soapy cotton balls to clean the surface. To remove gummy sticker residue, try a cotton ball dipped in a little rubbing alcohol, but never use strong solvents on a hand-painted or gilded surface.

Crazing, a spiderweb of tiny cracks in the glazed surface, is caused by quick changes in temperature. So never plunge a hot plate into cold water, or vice versa.

To prevent scratching, always dry plates with a very soft towel.

STORING DISHES

When it concerns the dishes you use every day, proper storage will help keep them in good shape. Don't stack them too closely together on shelves. And don't pile small plates on top of larger ones. Constant handling and moving to get to the size you need can cause nicking and breaking. Also, consider storing your dishes in a cupboard above

or near the dishwasher to avoid carrying them more than is necessary.

But perhaps you need to stow your holiday dishes until next year. Or maybe you just stumbled upon a vintage service for ten that you just had to have for those luncheon parties you plan to host one day. If you don't live in a pre–World War II house, when even modest homes often came equipped with a cupboard-lined butler's pantry or a china closet perfectly sited between kitchen and dining room, you need to find room to store them. Luckily, there's a whole industry devoted to the proper packing and storing of china.

First of all, with a glass-doored china cabinet or an open-shelved hutch you can put away the good stuff but still enjoy the beauty of the pieces. Remember that open shelves get dusty and so will your china, which may lead to more maintenance than you want to commit to.

If you're packing up pieces to store inside a cupboard, invest in padded storage cases that will protect against scratches, dust, and breakage. When stacking plates, always insert a felt plate protector between them (paper plates, paper towels, or layers of tissue paper will work, too) to avoid scratching.

For long-term storage, line the bottom of a box (or a plastic bin if the dishes will be stored in a location that could be damp) with packing peanuts, bubble wrap, or old towels. Wrap each plate in bubble wrap and line the plates up on their sides, so they're sitting on their rims (which will be protected by the layer of cushioning). Nestle like sizes together in a row. When the box is full, fill gaps on the sides and top with more peanuts. Ideally, the dishes will be firmly, but not too tightly, packed—you don't want the plates to jostle against each other or the sides of the box. Never pile boxes more than two high. Avoid storing dishes in the garage, attic, or any

place where the temperature fluctuates. Extreme changes between cold and heat can cause crazing and cracking.

REPAIRING DISHES

Nothing is quite so heartbreaking as a smashed dish, and nothing is also quite so inevitable. While pattern-hunting services have made it easy to find replacements for many pieces, sometimes an old dish is truly irreplaceable. Luckily, mending is not that complicated.

To do it yourself, first wash all the pieces in warm soapy water to remove any grease that may have built up, then let them dry thoroughly (at least an hour). Avoid quick-dry glues, which can set before you get a proper fit. Clear epoxy glue is usually best. Apply a thin coat to just one side—always use as little as possible to prevent buildup—then fit the pieces together. Use masking tape or rubber bands to hold all the pieces securely while they're drying. Let the repair cure for the full length of time indicated on the glue's instructions. You can wipe excess glue from the seam with a cotton swab dipped in a solvent such as acetone.

For especially fine pieces or complicated breaks, go to a professional restorer, who will be able to regild, reglaze, repaint, or even replicate missing parts as needed.

Back of the meticulously
repaired "Queen Victoria"
plate seen on page 372

SOURCES

Below are sources for purchasing the plates that appear in the book. The page number on which the plate appears follows contact information for each source. Plates not included here were borrowed from private collections and cannot be sourced directly.

RETAILERS

Anthropologie (anthropologie.com): pages 9 (right), 46 (bottom left), 178–79

Bardith, Ltd. (bardith.com): pages 6, 8, 10, 31, 36–40, 44, 46 (top left), 47, 54 (bottom left), 58, 66 (bottom), 84–85, 86, 132 (left), 141, 144 (right), 146–47, 204, 213, 245 (top), 247, 250–51, 287, 353 (top right), 355 (right), 356, 366

Bongenre (bongenre.com): page 236

Bulgar USA (bulgarusa.com): page 139 (both)

Calvin Klein Home (calvinklein.com): page 119

Childhood Antiques (childhoodantiques.com): pages 388, 390–93

The Shop at Cooper-Hewitt (shop.cooperhewitt.org): pages 175 (all), 176–77, 182 (right), 183

Diane von Furstenberg Home (dvf.com): page 117

Elise Abrams Fine Antiques for Dining (eliseabrams.com): title page (far right), pages 8–9 (center), 16, 25 (left), 26–27, 32–33, 35, 41–43, 50–53, 55, 59, 60 (all), 61 (all), 62–63, 64 (all), 102, 198 (left), 212 (bottom), 215–16, 217 (top), 240 (left), 241 (bottom), 248–49, 253, 254–56, 260–63, 266, 268, 270–72, 274–75, 285, 296, 303, 312–13, 355 (left), 360-61, 395 (both), 399

Fishs Eddy (fishseddy.com): pages 69 (far right), 77 (left), 233, 324 (both), 325–26, 347

Fred & Friends (fredandfriends.com): page 398

The Future Perfect (thefutureperfect.com): page 186

The Herrs Antiques (theherrsantiques.com): page 135

Jane Jenni (janejenni.com): pages 400–401

Just Scandinavian (justscandinavian.com): pages 25 (right), 237

Kneen & Co. (kneenandco.com): pages 80, 129 (right), 235 (left)

La Terrine (laterrinedirect.com): pages 130 (top), 131, 145 (left), 362–63

Lekven Design (dogplate.com): pages 278–79

Lenox (lenox.com): pages 112, 114, 118, 281

Let's Talk Turkey Vintage Tabletop (rubylane.com/shop/letstalkturkey): pages 376–81

Mood Indigo (moodindigonewyork.com): pages 15, 18, 49 (all), 92–93, 103, 106, 294–95, 320–21, 330–33, 350–51, 365

The Museum of Modern Art Store (momastore.org): page 48 (top and bottom)

Moss (mossonline.com): pages 65, 128 (bottom), 129 (right), 174, 180–81, 230 (top)

Mottahedeh (mottahedeh.com): pages 13 (right), 185

The Mount Vernon Shop (mountvernon.org/shop): title page (far left), page 12 (bottom)

Neue Galerie Design Shop (shop.neuegalerie .org): page 71 (far right)

Pottery Barn (potterybarn.com): page 46 (top right)

Ralph Lauren Home (ralphlaurenhome.com): page 113

Replacements, Ltd. (replacements.com): title page (center), pages 7, 13 (bottom left), 14 (bottom), 22–24, 28–29, 34, 45 (all), 54 (top left, top right, bottom right), 56–57, 66 (top), 67–68, 69 (top left and bottom), 70–71, 81 (all), 83 (both), 88–91, 94–95, 100, 101 (all), 108–10, 121, 144 (left), 145 (top right), 172–73, 187, 206–11, 212 (top), 217 (bottom), 220–27, 230 (bottom), 238–39, 255, 286, 290–291, 296, 302 (both), 308, 309 (all), 327, 344, 353 (left), 382–87, 403

Rosenthal (rosenthalusa.com): page 116

ZEBRA BY TERRAFIRMA CERAMICS

Ross Svcback (rosssvcback.com): page 235
Steven S. Powers Antiques (burlsnuff.com):
page 134
Wedgwood (na.wwrd.com): page 115

FEATURED ARTISTS AND POTTERS
Eve Behar (evebeharceramics.com): page 163
Don Carpentier (greatamericancraftsmen.org/
store): page 168
Alison Evans (aeceramics.com): pages 148–49
Ellen Evans (terrafirmaceramics.com): page 162
Pat Girard (girardstoneware.com): page 160
Gorky González (gorkypottery.com): page 164
Ellen Grenadier (grenadierpottery.com): page 161
Hadley Pottery (hadleypottery.com):
pages 166–67
Molly Hatch (mollyhatch.com): page 190
Florian Hutter (thenewenglish.co.uk): page 192
Jugtown Pottery (jugtownware.com): page 155
Lenore Lampi (lenorelampi.com): page 169
Daniel Levy (daniellevyporcelain.com): page 450

McCarty's Pottery (mccartyspottery.com):
page 157
Marcie McGoldrick (marciemcgoldrick.com):
page 234
Michele Michael (elephantceramics.com):
page 158
Ana Mir (emilianadesign.com): page 188
Nicholas Mosse (nicholasmosse.com):
page 165
Lisa Neimeth (lneimeth.com): pages 170–71
Asya Palatova (gleena.com): pages 152–53
Frances Palmer (francespalmerpottery.com):
page 154
Jill Rosenwald (jillrosenwald.com): page 156
Cindy Sherman (artesmagnus.com): page 191
Miranda Thomas (shackletonthomas.com):
page 159
Paul Timman (inkdish.com): page 193
James Victore (jamesvictore.com): page 189
Kristen Wicklund (kristenwicklund.com):
pages 150–51

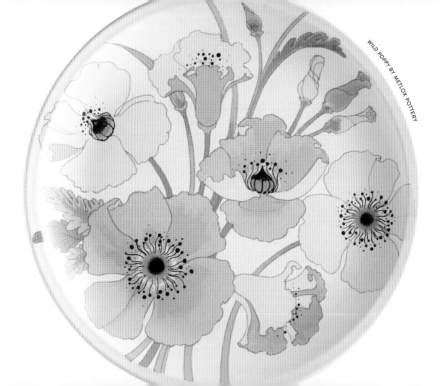

WILD POPPY BY METLOX POTTERY

ACKNOWLEDGMENTS

PORCELAIN PLATES BY DANIEL LEVY

I T TAKES *A LOT* OF HELPFUL people to gather and photograph hundreds of fragile objects. Huge thanks to the following antiques dealers, retailers, and collectors who loaned me pieces: Elise Abrams, Nancy Barshter, David Bartolomi, Daniel Basiletti, Ria Boemi, Christopher Bryant, Pamela Burleigh-Konopka, Myron Chefetz, Lisa Conklin, Jorge De La Garza, Deborah Friedman, Julie & Dave Gaines, Korina Gregory, Todd Hall, Dr. & Mrs. Donald M. Herr, Sam Herrup, Lee Kaplan, Kathleen Kleinsmith, Zuzka Kurtz, Robin Long, Gloria Grayeb Manning, Reed Maroc, Murray Moss, Naomi Nomikos, Jeffrey Opdyke, Bob Page, Russell Perreault, Diane & Bob Petipas, Shane Powers, Steven S. Powers, Pat Riegler, Doug Roche, Carol & Norman Schnall, Bonnie Slotnick, Carolyn Sollis, Claire Voulgarelis, Carol Walsh, Edith Wolf, and Steve Wolf. Thanks to everyone at Artisan over the years. And to photographer Robert Bean and and his assistant Scott Sanders, whose incredible patience and attention to detail over many months kept this project on track.

PHOTOGRAPHY
CREDITS

NINETEENTH-CENTURY WEDGWOOD PLATE

All photographs are by Robert Bean except for those listed below.

Pages 1 and 114: Donna Karan plates, courtesy of Lenox; **pages 2–3 and 71:** *Flora Danica,* courtesy of Royal Copenhagen; **pages 12 and 173:** Sèvres "Cameo" portrait plate, courtesy of Sotheby's; **page 19:** *Fiesta* shelves, courtesy of Replacements, Ltd.; **pages 66–67:** *Vieux Luxembourg,* courtesy of Villeroy & Boch; **page 69:** *Blue Fluted Lace,* courtesy of Royal Copenhagen; **page 70:** *Ming Dragon,* courtesy of Meissen; **page 80:** Ted Muehling plate with painted crack, courtesy of Porzellan Manufaktur Nymphenburg/Kneen & Co.; **page 112:** Marchesa plate, courtesy of Lenox; **page 116:** *Byzantine Dreams,* courtesy of Rosenthal China; **page 117:** *Sun Stripe,* courtesy of DVF Home; **page 118:** *Larabee Road,* courtesy of Lenox; **pages 128–29 and 155:** courtesy of Jugtown Pottery, photos by Travis Owens; **pages 152–53:** courtesy of Asya Palatova; **page 154:** courtesy of Frances Palmer; **page 156:** courtesy of Jill Rosenwald; **page 158:** courtesy of Michele Michael (Elephant Ceramics); **page 159:** courtesy of Miranda Thomas (ShackletonThomas), photo by Thomas Ames, Jr.; **page 160:** courtesy of Girard Stoneware; **page 161:** courtesy of Ellen Grenadier, photo by John Polak; **page 163:** courtesy of Eve Behar, photos by Caryn Leigh Photography, LTD; **page 165:** Courtesy of Nicholas Mosse Pottery; **pages 166–67:** courtesy of Hadley Pottery; **page 168:** courtesy of Don Carpentier; **page 169:** courtesy of Lenore Lampi; **pages 170–71:** courtesy of Lisa Neimeth; **page 185 and 444:** Monet plates, courtesy of Robert Haviland & C. Parlon/ Mottahedeh; **page 186:** *New York Delft,* courtesy of The Future Perfect; **page 188:** *The Hair Disguiser Dish,* courtesy of Emiliana Design Studio, photograph by Xavi Padrós; **page 189:** *Dirty Dishes* plate courtesy of James Victore; **page 190:** courtesy of Molly Hatch; **page 191:** *Madame de Pompadour* plate, courtesy of ARTES MAGNUS Limited Editions, New York, NY; **page 192:** *Inkhead,* courtesy of The New English; **page 193:** *Irezumi,* courtesy of Ink Dish; **page 235:** *Enchanted Forest,* courtesy of Porzellan Manufaktur Nymphenburg/Kneen & Co.; *Faux Bois,* courtesy of Ross Sveback; **pages 314–15:** *New England Industries* series, courtesy of Replacements, Ltd.; **pages 404–37:** top 100 plates, courtesy of Replacements, Ltd.; **page 450:** Courtesy of Daniel Levy.

ABOUT THE AUTHOR

STANGL POTTERY'S LITTLE QUA

SHAX RIEGLER loves dishes. His first foray into dish collecting began about fifteen years ago, when he picked up a nearly full service for twelve of Noritake's *Bambina* (see page 232), even though he was living in a studio apartment at the time! He is the executive editor of *House Beautiful* and is also completing a PhD from the Bard Graduate Center for Studies in the Decorative Arts, Design, and Culture. Please visit his website: shaxriegler.com.